Barkcloth

Aspects of Preparation, Use, Deterioration, Conservation and Display

*The views and practices expressed by individual authors
are not necessarily those of the editor or the publisher*

Also available in the Conservators of Ethnographic Artefacts series

Ethnographic Beadwork: Aspects of Manufacture, Use and Conservation

Forthcoming

The Conservation of Fur, Feathers and Skin
The Conservation of Ethnographic Painted Surfaces

C.E.A.
Conservators of Ethnographic Artefacts

Barkcloth

Aspects of Preparation, Use, Deterioration, Conservation and Display

Seminar organised by the Conservators of Ethnographic Artefacts
at Torquay Museum on 4 December 1997

Edited by

Margot M. Wright

CEA Series No. 2

Archetype
Publications

First published 2001 by Archetype Publications Ltd.

Archetype Publications Ltd.
6 Fitzroy Square
London W1T 5HJ

www.archetype.co.uk

Tel: 44(207) 380 0800
Fax: 44(207) 380 0500

ISBN 1-873132-82-4

Typeset by Kate Williams, Abergavenny
Printed and bound in Great Britain by Henry Ling Ltd., The Dorset Press, Dorchester

Contents

Contributors

Vincent Daniels Senior Research Scientist, the British Museum, Department of Scientific Research, Great Russell Street, London WC1B 3DG.

Sherry Doyal Ethnographic Artefact Conservator, 2 Bullfinch Close, Colebrook Chase, Cullompton, Devon EX15 1UU.

Rowena Hill Artefact Conservator, Chepstow Museum, Gwy House, Bridge Street, Chepstow, Monmouthshire NP16 5EZ.

T. Rose Holdcraft Object Conservator, the Peabody Museum of Archaeology and Ethnology Harvard University, Department of Conservation, 11 Divinity Avenue, Cambridge, Massachusetts 02138, USA.

Emily Johnson 105 Peperharow Road, Godalming, Surrey CU7 2PN.

Christine Murray Regional Conservator, the National Trust, East Midlands Regional Office, Clumber Park Stableyard, Worksop, Nottinghamshire, S80 3BE.

Len Pole Curator of Ethnography, Royal Albert Memorial Museum, Queen Street, Exeter EX4 3RX.

Morwena Stephens Independent Textile and Ethnographic Artefact Conservator, Royal Albert Memorial Museum, Queen Street, Exeter EX4 3RX.

Foreword

On 2 and 3 December 1997, a two-day workshop on the technology and conservation of tapa (barkcloth), organised by the Conservators of Ethnographic Artefacts (CEA) and tutored by Ruth Norman, was hosted by the Royal Albert Memorial Museum (RAMM), Exeter. The workshop was followed by a seminar on 4 December 1997 at Torquay Museum.

This is the second of the CEA series on the conservation of ethnographic artefacts, containing all of the papers presented at the seminar. The papers describe information gathered in the field in Ghana and Papua New Guinea, methods of surveying museum collections, non-interventive and interventive methods of conservation as well as aspects of display.

The CEA Committee would like to thank the Royal Albert Memorial Museum and Torquay Museum for their support and the authors for allowing the information to be published.

The CEA Committee Members who organised and ensured the smooth running of the workshop and seminar were Sherry Doyal, Rowena Hill, Alison Hopper Bishop, Claire Robinson, Lorraine Rostant and Morwena Stephens.

Margot M Wright
June 2001

◆1◆

African barkcloth,
with particular reference to Ghana

Len Pole

Introduction

Barkcloth is normally portrayed in Africa as the poor relation of woven cloth, only surviving where the latter is not significant, or only worn by people who cannot afford 'better'. The topic has a long history; it is unfortunate that those few who have given it even a passing interest have only been able to record the dying embers of a craft formerly much more significant.

Geographical range

The production of barkcloth has been recorded from Liberia, Ivory Coast, Ghana, Togo, Nigeria, Cameroon, Congo, Sudan, Uganda, Rwanda, Tanzania, Malawi, Madagascar, Zambia and South Africa. The main difference in the look of the material from west Africa and east Africa is that the west African form is whitish/grey, whereas that from Uganda and Tanzania is brown, resulting from oxidisation in the sun (although the white form has been reported in Uganda as being the particular prerogative of chiefship). In Uganda the species of tree used was a species of fig, *Ficus natalensis*. In Ghana *Antiaris* species were used; this may have some slight influence on the colour and flexibility of the finished cloth.

1

Decorating the cloth

Decoration has been recorded for examples in Uganda, mostly using stencils made from banana leaf, but the technique is said to be shrouded in mystery (Picton and Mack 1989: 167). Freehand designs are known from Nigeria and Congo (Picton and Mack 1989: 47; Seiber 1972:159; Trowell 1960: pl. 26).

Uses

Reported uses of barkcloth in Africa have included the following:

- ordinary clothing (e.g. for hunting, in Asante and Boso, Ghana);
- ceremonial clothing (e.g. of the Asantehene during *Odwira* ceremonies in Ghana; masquerade costume in Igala, Nigeria; as ceremonial costume for chiefs and their successors in Baganda, and as costume of the ancestors in Kuba kingdoms of the Democratic Republic of Congo)
- as bedding (Ghana, Uganda)
- as a surface in a building (on the floor of the king's palace Uganda, hung from the ceiling in Asante)
- as shroud material (in Baganda, Bunyoro)
- and most recently, as examples of craft items for tourists.

Manufacture in Ghana

What follows is an edited version of a field report written after a single day's visit to the village of Boso, in the eastern region of Ghana in March 1973 while working for the Ghana National Museum in Accra.

Having greeted the chief and presented him with some schnapps for pouring libation, we arrived at the compound of Kwadwo Gyem, the barkcloth-maker, at about 1pm. He had already cut a specimen of the barkcloth tree (called *kyenkyen* in Twi the 'lingua franca' of the area; *ofu* in Guang, the language spoken by the people of Boso) and brought it to the place where he was to work.

The log was placed on the ground and beaten with a smooth wood hammer; this loosened the bark from the trunk (Fig. 1.1). After 25 minutes this was completed and a locally made knife (*adwudwo* in Guang) was used to make a longitudinal cut in the bark (Fig. 1.2). From this cut the bark was stripped off

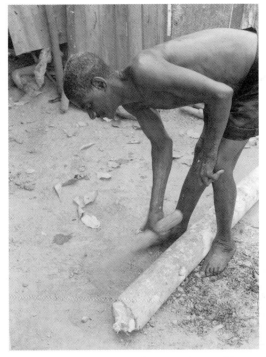

Figure 1.1 Bark on the trunk beaten with a wood hammer

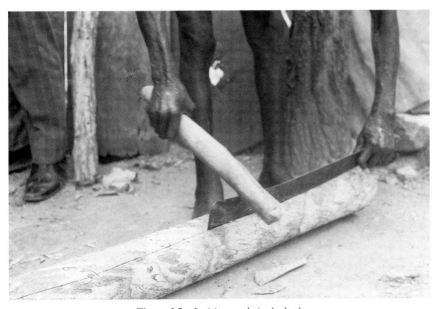

Figure 1.2 Incision made in the bark

with the help of a sharpened wood stick (*ndame* in Guang) (Fig. 1.3). Once the bark was free, the outer rough part was separated from the inner bark, from which the cloth was to be made (Fig. 1.4). This was done by making a lateral cut with the knife, prizing up the inner bark and pulling it away from the outer; the former was held with the hand, the latter with the foot. Some difficulty was found in this operation. The reason for this was the low humidity. This was because, being March, it was the dry season, and the harmattan (the dry wind from the Sahara) was unusually severe for this part of the country; were it the wet season, the period of the year when barkcloth was traditionally made, there would have been no such difficulty.

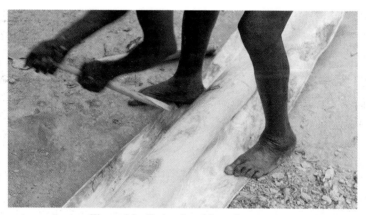

Figure 1.3 Bark stripped from the tree

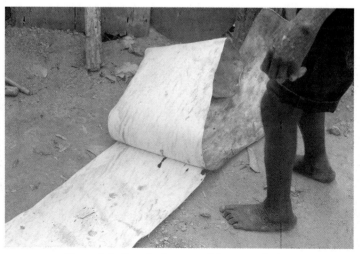

Figure 1.4 Inner bark separated from outer bark

4

Once the inner bark was separated, it was placed on a horizontal wood beam (Fig. 1.5) supported at waist level by a Y-shaped post at each end, and beaten with a laterally ridged wood beater (Fig. 1.6). The beam is called *ayitente* in Guang, the wood coming from the *ngwono* tree (*sinna* in Twi) although it may be any tree having hard wood; the beater is *abore ayifore* in Guang, *ayitin* in Twi and can be made from any hard wood. The beater was used diagonally, so that the fibres of the bark were spread out. It took 40 minutes to beat the bark in one layer after which there was not much visible spreading. However, when the bark was folded and beaten again with the ridges along the opposite diagonal the expansion was very noticeable (Fig. 1.7). The double layer was

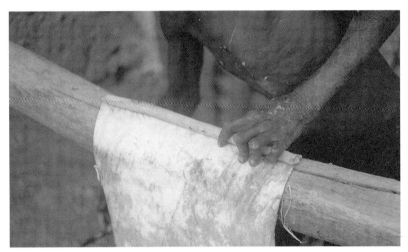

Figure 1.5 Inner bark placed on horizontal wood beam

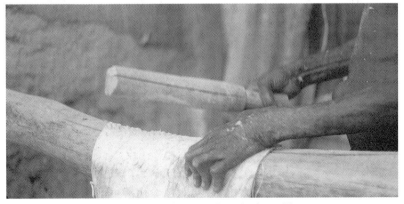

Figure 1.6 Bark beaten with a ridged wood beater

beaten on both exterior surfaces; this took 30 minutes. Then the cloth was folded again along the same side making four layers (Fig. 1.8), and beaten; folded again, making eight layers and beaten for the last time. It was rolled up and washed thoroughly (Fig. 1.9).

Two split sticks were used to squeeze the water out of the cloth. Each end of the folded material was inserted into one of the split sticks and securely bound with a vine (*noto* in Guang, *mpahoma* in Twi) (Fig. 1.10). One stick was

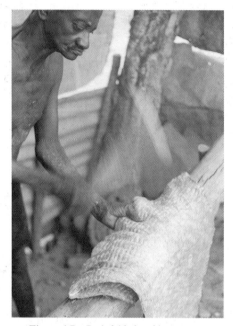

Figure 1.7 Bark folded and beaten again

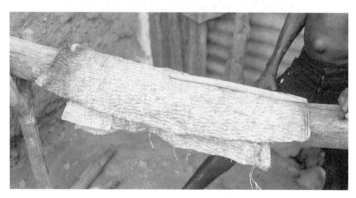

Figure 1.8 Bark now doubled in width

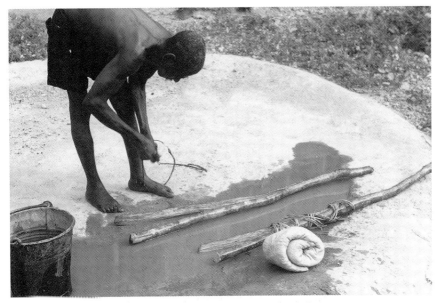

Figure 1.9 The cloth folded in washed on a mud platform

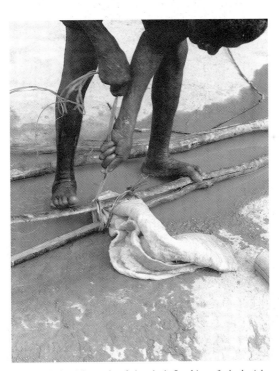

Figure 1.10 The ends of the cloth fixed into forked sticks

lodged behind two adjacent trees, the other was rotated until all the water had been wrung out (Fig. 1.11). The squeezers are called *akyide* (Guang) and can only be made from a branch of the *akomkomiri* tree. The cloth was unfolded and pegged out on the ground, being stretched as much as possible (Fig. 1.12); the pegs are made of bamboo and are called *mfewa* (Guang) or *mkewa* (Twi). The cloth was dried for three hours in this position after which it was ready to use. The name for barkcloth in Guang is *ofuta*.

The cloth is used mainly to sleep on; it is said to be impermeable to ticks and other kinds of bedbugs. It is also used in making shoulder bags.

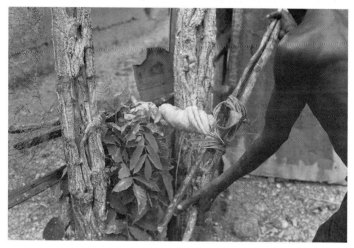

Figure 1.11 Excess moisture squeezed out of the cloth

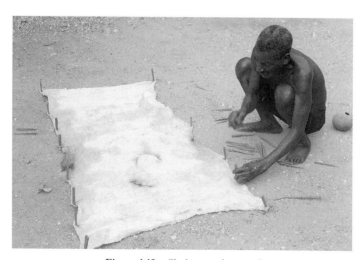

Figure 1.12 Cloth pegged out to dry

References

I have not undertaken an extensive literature search in the preparation of this article, but the following references have been consulted:

McLeod, M. D. (1981) *The Asante*. London: British Museum Publications.

Nzita, N. and Mbaga–Niwampa (1993) *Peoples and Cultures of Uganda*. Kampala: Fountain Publishers.

Picton, J. and Mack, J. (1989) *African Textiles*. London: British Museum Publications.

Rattray, R. S. (1927) *Religion and Art in Ashanti*. Oxford: OUP.

Seiber, R. (1972) *African Textiles and Decorative Arts*. New York: Museum of Modern Art.

Trowell, M. (1960) *African Design*. London: Faber & Faber.

Condition survey of barkcloth at Exeter City Museums, with particular reference to the African collections

Sherry Doyal

Introduction

During 1997 the author and Len Pole, Curator of Ethnography, undertook a survey of the barkcloth within the collection, working on average two days per week over a period of months. The value of surveys in conservation has been questioned but the author's experience was positive for the following reasons:

- the curator and conservator respectively brought to the examination process a different set of observational skills and familiarity with relevant literature
- both were new to their respective jobs having started work three months before the survey was begun; surveys are a systematic way of familiarising staff with collections and with each other
- during the course of the survey, examination skills were refined or extended so that a checklist was developed (see Appendix 1).

The survey established the value of the following examination practices:

- a raking light and linen counter used to examine beater texture
- an illuminated pocket microscope used to examine details
- a hand-held ultraviolet (UV) light for the examination of decorative techniques and stains
- a light box (transmitted light) used to examine seam structures and density of the barkcloths
- field and standard tape measures, scales and a (very) tall ladder were required for documentation and photography.

Curator's objective

The curator's objective was to add to the documentary record photographs and detail as well as looking for items for new exhibitions. A minimum of two barkcloths of outstanding quality had already been identified but it was thought that a further six were required to illustrate a range of techniques of manufacture. In addition, for the purposes of display barkcloths were to be identified that would be suitable for rotation every three to five years. At the beginning of the survey, paper records indicated that the collection housed 77 barkcloths from Hawaii, Tahiti, Samoa, Fiji and Africa. Further examples of barkcloth in the collections from other geographic origins were identified because of the increased awareness of the material generated by the survey.

The survey meant that facilities, which would not have been used for routine work, were made available for examination of the barkcloths. The most obvious of these was the provision of sufficient space to open out and examine large barkcloths; previously this had been impossible in the space allocated for the storage of ethnographic artefacts or the conservation laboratory. A temporarily closed gallery, furnished with a block of lightweight wallpaper pasting tables, was used for the examination of the barkcloths. Very large examples were examined on a ground sheet of seamed Tyvek (spun-bonded polyethylene olefin). The most exciting discovery was that several boxes that had been labelled as plain barkcloth of African origin were found to contain large, decorated barkcloths of fine quality. It appears that the box had been opened, the barkcloth subjected to a cursory glance and that the presence of deep, undecorated borders had misled the labeller.

Conservator's objective

The conservator's objective was to expand an already existing condition survey of the collections (see below) and to obtain practical work-planning information for a forthcoming exhibition. This included:

- treatment space required
- estimates of time
- materials required for treatment
- repackaging and project display.

During the survey, gloves were used for handling and repackaging materials were used to address worst-case storage problems although it should be stressed that repackaging was not an objective of the survey. One of the

outcomes of the survey was that the information required to fund-raise for the repackaging was collated. Repackaging, funded with designated monies based on the survey, will be completed in 2001.

The conservation department at Exeter City Museums was engaged in a conservation survey, recording accession numbers, brief descriptions, current locations, condition, proposed treatment, preventive (packaging, extra mounting for storage) and interventive treatments (reshaping, cleaning, stabilisation and additional work required for display) (Keene 1996). The survey sheet contained columns for predicted volume increases after repackaging and remarks/action. Estimates of the work required were calculated. In practice, occasionally more detailed estimates were prepared when the proposed treatments required more than 35 hours in order to check the accuracy of the estimate. Also, a few barkcloths were surveyed by two conservators to try to maintain consistency of standards in the preparation of the estimates.

The African barkcloths

Ten African barkcloths were located in the collections' survey with examples from the Ivory Coast, Ghana, Southern Sudan and Uganda. The Bagandan people, who are regarded as the finest makers of African barkcloth, recognise 50 distinct types of barkcloth (Nzita and Mbaga-Niwampa 1995). Therefore the collection, because of its small size, could not represent all of the types described. Texture, colour and surface decoration must be considered during examination and treatment of barkcloths.

Texture

The texture may be due, in part, to the source plant of the fibre and/or to the processing of the cloth. African barkcloth is often made from the genus *Ficus*, of which there are some 600 species. One example, Royal Albert Memorial Museum (RAMM) 8/1920 is made from *Ficus kotschyana*, known as *rokko* in the Zande language. The barkcloth, produced in Ghana and described by Len Pole (see Chapter 1) is made from *Ficus antiaris* ssp., known as *olu* in the Guang language (*kyenkyen* in Tui), the cloth being called *ofuta*. The Ugandan barkcloths are made from *Ficus natalensis*, known as *omutuba* in the Bantu language.

Accounts from Uganda tell of plantation-grown *Ficus* trees some eight feet in height, each with a straight trunk and umbrella-like foliage. When the trunk

of the tree is six inches in diameter, the bark is removed. The trunk, when bandaged, will yield one piece of bark per year for six years; the bark collected in the third year is considered to be of superior quality (Picton and Mack 1989). Alternatively the tree may be cut down and the bark stripped like a stocking and forming a continuous tube such as RAMM 88/1932 from the Ivory Coast.

The bark is beaten on a wooden anvil with a mallet which causes the bark to increase in width some five times and in length by about one-tenth. To obtain larger sheets of barkcloth, pieces are sewn together using raffia (*jupati* palm leaf cuticle fibre). The heavy, hard, wooden beaters called *ensaamu* in Baganda are grooved or crosshatched (Picton and Mack 1989). To the west, in Zaire, the beaters may be made from elephant or boar tusk ivory (Ayo 1995). The RAMM collection contains examples of grooved beater cloth from Uganda (RAMM 35/1929, 60/1948) and diced beater cloth from Sudan (RAMM 8/1920). Conservators must be aware that treatments using humidification may cause the loss of definition of beater impressions. Additionally, Len Pole's fieldwork based on the production of barkcloth showed that the barkcloth may be staked out and allowed to dry. Therefore, it is possible that during humidification and relaxation, shrinkage may occur, indicating that the use of drying templates is advisable. During the conservation treatment of RAMM 39/1929, 'sandwich humidification' (Keyes 1988) was continued until a slightly floppy stage was reached. The wet blotters were removed at this point and the barkcloth was lightly blanket-weighted to reduce movement during drying. Beater definition is still good but heavy creases were not completely removed.

Colour

The ground colour of the bark may vary due to tree source or processing. Steaming, using bark bundled in banana leaves heated over green logs, changes the colour of *Ficus* bark 'from a brownish colour to a rich yellow' (Picton and Mack 1989: 43). The effects of smoke on barkcloth have not been broadly considered but observations about skin products may be relevant. The process of smoking 'may impart colour, fragrance, additional waterproofing and resistance to insects' (Howatt-Krahn 1987: 44); cold-smoking is a drying process for brined skins. The type of wood used for the smudge may influence colour; in skins, alder produces a red tinge, dry willow a yellow tinge, and green willow a brown tinge (Laubin and Laubin 1977). The preservation of scent may be a conservation issue; the scent may act as a perfume or it may be an insect deterrent (Johansen 1999).

Retting, the process of removing other plant materials from the bast fibres, may affect colour e.g. dew-retted linen is darker in colour than running water-

retted linen. Retting may take place in fresh, salt, flowing or still water or in mud. Conservators should consider the possibility of salts being drawn from salt-retted material by drying after wet or humidification treatments. Also salts may act as humectants, drawing moisture into the barkcloth; RAMM Loan B No. 83 exhibits overall white deposits that may be due to salt retting. Mud retting may cause organic stains or mineral salts to impart colour to the barkcloth. In *Allan Quatermain*, H. Rider Haggard gives an account of coconut salt-water retting in Lamu on the East African coast of Kenya. This is a work of fiction but from 1885 until 1880, Rider Haggard did colonial service in Africa and was a friend of the anthropologist Andrew Lang, therefore the observation may be sound. Rider Haggard (1994: 21) notes:

> Just below the Consulate is the beach, or rather a mud bank that is called a beach. It is left quite bare at low tide, and serves as a repository for all the filth, offal and refuse of the town. Here it is, too that the women come to bury cocoanuts in the mud, leaving them till the outer husk is quite rotten, when they dig them up again and use the fibres to make mats with, and for various other purposes. As this process has been going on for generations, the condition of the shore can be better imagined than described. I have smelt many evil odours in the course of my life, but the concentrated essence of stench which arose from that beach at Lamu . . . makes remembrance of them very poor and faint.

Oxidation of drying barkcloth after beating can contribute to the colour of the barkcloth. In 1902 Reverend Roscoe observed that processed barkcloth was laid on the ground in the sun to dry and became a terracotta colour on the exposed side, while the unexposed side was lighter in colour and almost yellow (Brigham 1976). Ugandan barkcloths RAMM 35/1929 and 60/1948 both exhibit this difference in colour on the front and back of the barkcloths.

Palm oil sprayed by mouth was said to leave the barkcloth the colour of chamois (an oil-tanned leather). Oils may attract soiling and they may cross-link causing embrittlement and acidification. The presence of oil may prevent the use of humidification treatments and water-soluble adhesives for repair.

Surface decoration

The ten RAMM African barkcloths include six examples with surface decoration. Each has a dark pattern on a red/brown substrate, and each appears to

be hand-drawn or simply press-printed. The patterns are framed rectangles or squares (a similar example is illustrated in Picton and Mack (1989: 167)). The patterns are described below:

- *Crabtree loan*: two square fields, one divided across the diagonals into four sectors. Fields filled with dots, zigzags, stripes
- *RAMM 60/1948. 110a*: two square fields, one filled with stars in boxes and the other with broad stripes, zigzags and dots
- *RAMM 60/1948. 110b*: two square fields filled with circles and dots
- *RAMM 60/1948. 110c*: two square fields filled with three broad strips of stars
- *RAMM 60/1948, 110d*: two square fields filled with stars in boxes
- *RAMM 35/1929*: two rectangular fields filled with circles, framed by dotted borders

Patterned cloth may be decorated with stains or pigments. Gardenia juice may be used for staining (Phillips 1996). Gardenia is in the order *Rubiaceae*, which includes the important dye plant madder. Pigments may be naturally occurring or they may need to be prepared as described by Brigham (1976: 69) 'sometimes patterns in black from clay found in swamps, or from a preparation made from charred wood and oil are painted on the cloths to make them more valuable'. The use of laundry blues in ethnographic objects has been considered elsewhere (Odegaard and Crawford 1996; Barton and Weik 1998). Conservators should bear in mind the possibility of its occurrence in barkcloth. The surface decoration on RAMM 60/1948. 110b has the green/blue cast and bronze sheen associated with Prussian blue (in use since about 1724). The colour, ferric ferrocyanide, is decomposed by alkalis and heat to produce ferric hydroxide. Therefore this excludes the use of deacidification treatments such as magnesium bicarbonate solutions (Clapp 1978) as the surface decoration may be altered to form stains of rust.

Other barkcloths

The barkcloths recorded in literature are not all of the beaten type, which is the subject of this paper. In Zimbabwe, '*Gudza*, bark fibre blankets are made from the *msasa* tree' (National Gallery of Zimbabwe 1983: 27). These are free-woven (without a loom) from cordage prepared from pounded and rolled bark fibres. A 16th-century Portuguese wrote accounts of the Batonga people of the Mutoko area, who used bark as dress and for containers:

they cut the tree and hit it with sticks shaped like hammers and start stripping it and blows break the outer hardness whilst the webbing is left inside. That which they use for containers is like cork and they weave the inner bark together, namely to cover themselves (blankets) by night. (Ellert 1984)

To conclude, the barkcloth survey was valuable in identifying new areas of documentation, treatment, display and research to be pursued at the museum.

References

Ayo, Y. (1995) *Africa*. Eyewitness Guides. London: Dorling Kindersley, 20.

Barton, G. and Weik, S. (1998) 'Blue in the Pacific', *SSCR Journal* **4**, 15–17.

Brigham, W. T. (1976) *Ka Hana Kapa. The Making of Barkcloth*. New York: Millwood.

Clapp, A. (1978) *Curatorial Care of Works of Art on Paper*. Oberlin, OH: Intermuseum Conservation Association.

Ellert, H. (1984) *The Material Culture of Zimbabwe*. Zimbabwe: Longman.

Howatt-Krahn, A. (1987) 'Conservation: skin and native-tanned leather', *American Indian Art Magazine* **12**(2), 44–51.

Johansen, K. (1999) 'Perfumed garments their presentation and, presentation . . . "the good smell of old clothes" (R. Brooke, 1837–1915, The Great Lover)'. Preprints of *ICOM-CC 12th Triennial Meeting*, Lyon, Vol. II, 29 August–3 September 1999, 637–42.

Keene, S. (1996) *Managing Conservation in Museums*. London: Butterworth-Heinemann.

Keyes, K. M. (1988) 'Some practical methods for the treatment with moisture of moisture-sensitive works on paper'. *Symposium 88*. Ottawa: CCI, 99–107.

Laubin, R. and Laubin, G. (1977) *The Indian Tipi, its History, Construction and Use*. Oklahoma: University of Oklahoma Press.

National Gallery of Zimbabwe (1983) *The Metal Box Crafts Exhibition*. Norman: University of Oklahoma Press.

Nzita, R. and Mbaga-Niwampa (1993) *Peoples and Cultures of Uganda*. Kampala: Fountain Publishers.

Odegaard, N. and Crawford, M. F. (1996) 'Laundry blueing as a colourant in ethnographic objects'. Preprints of *ICOM 11th Triennial Meeting*. Edinburgh.

Phillips, T. 1996. *Africa – the Art of a Continent*. London: Royal Academy of Arts.

Picton, J. and Mack, J. (1989) *African Textiles*. London: British Museum Press.

Rider Haggard, H. (1994) *Allan Quartermain*. Ware: Wordsworth Editions.

Bibliography

Sieber, R. (1972) *African Textiles and Decorative Arts*. New York: Museum of Modern Art.

Spring, D. (1989) *Textiles*. London: Braken Books.

Appendix 1

Barkcloth Survey: an information checklist[1] (2nd edition, 1997)

Tools and techniques

Pasting tables, latex gloves, a thread counter (linen tester), illuminated pocket microscope, torch (for raking light), hand-held ultraviolet (UV) light, long tape measure, camera + ladder + scale.

Useful observations

Identifiers
• Accession number and other labels
• Dimensions
• Thickness where measurable. (If a micrometer is not available, a simple thickness gauge can be made using swatches of Melinex/Mylar of different known thicknesses.)
• Flexibility/'hand'

The cloth
• Grain direction i.e. direction of plant fibres. Does it run with the length or width of the barkcloth?
– Which way is up?
• Beater
– Can beater marks be seen?
– Can beater marks be counted with a thread counter inch and 10mm square?
– Is there any evidence of more than one size used?
- Do they run across or with the fibre direction?
• How are the natural holes filled?
• Pieced?
• Type of join?
– Stuck or beaten?
– Bird mouth?
– Overlap?
– Sewn?

1. Based on Keene (1996: 142–3) and the Rocky Mountain Centre Basketry Survey Report obtained by the author when on a private visit.

Surface decoration

- Background colour?
- Surface decoration colours and technique?
- – Rubbed?
- – Stencilled?
- – Free hand?
- – Block printed?
- – Appliqué?
- – Embroidery?
- – Beadwork?
- Matt and gloss areas?
- Burnished/polished?
- Glaze or other surface coating?

Finish of margins

- Cut?
- Torn?
- Pinked?
- Hemmed? Turned by sewing or adhesive? Or bound?

Condition[1]

- Excellent/Good/Fair/Poor
- Structural damage
- – Major? Loss/shedding/ delamination/cracking
- – Minor? Tears/breaks/holes/distortion/ weak joints
- – Surface? Flaking/powdering
- Disfigurement
- – Scratched
- – Stained
- – Abraded
- – Discoloured
- – Faded
- – Colours bled
- – Labels
- Chemical
- – Friable
- – Dry/brittle
- – Exudations
- – Grease
- – Surface salts
- Biological

– Active or passive?
– Insects (moth/furniture beetle etc)
– Mould
– Foxing
– Mildew
• Accretions
– Dirty
– Encrustations
– Deposits
• Previous repair? Unstable, unaesthetic, inappropriate
– Adhesive
– Sewn
– Additions (patches, tape)
• Previous display?

Treatment

• Surface clean
• Humidify
• Condition fibres
• Consolidate
• Local repairs (glue/fibres)
• Back weakness
• Back losses
• Reassemble
• Reshape
• Fumigate
• Auxiliary support
• Clean (water/solvent/chemical treatment)
• Repair or restore
• Remove repairs or remove restoration
• Remove coating

◆3◆

Research into the deterioration of barkcloth

V. Daniels

Introduction

The deterioration of ethnographic plant materials is probably the least studied area in artefact conservation. A good example is barkcloth (tapa) of which many museums have collections. While most objects are in excellent condition, many collections have a few barkcloths which appear to be degrading faster than the others. The reasons for this deterioration are largely unknown.

In the British Museum for the last three years, research on artefacts made of plant materials has concentrated on the deterioration and stabilisation of black-dyed New Zealand flax (*Phormium tenax*), which degrades much faster than undyed flax. In the course of this research the understanding of the processes of the degradation of ethnographic fibres has been advanced. When considering the reasons for the deterioration of plant materials, parallels between the factors that govern the degradation of paper and different kinds of cellulosic plant materials are drawn as they have common constituents; but some important differences also exist.

Plant fibres

All plant fibres contain principally cellulose, hemicellulose, lignin and some water. Of these materials, cellulose is the most stable and contributes most to the toughness of the fibre while lignin contributes to the stiffness. *P. tenax* has a high hemicellulose content of about 30%, indeed cleaned *P. tenax* fibre contains less than 50% cellulose, the lowest cellulose content of all the

20

commercially available fibres. Research has shown that solubility of these materials in hot water and 1% solutions of hot sodium hydroxide increases as degradation increases, and this may be used to follow the processes of degradation. In black-dyed *P. tenax*, the rate of degradation has been shown to increase with the concentration of iron in the fibre, which originates from the applied black iron/plant polyphenol dye. Iron is an important oxidation catalyst and accelerates degradation of cellulose and hemicellulose, however, it is believed that the iron has to be released from the dye complex in order for it to be able to participate in degradation reactions. Hemicelluloses often contain large amounts of acetyl groups, which are capable of reacting with water to release acetic acid. This acid may react with the dye complex to free iron for chemical reactions or may participate in acid hydrolysis of cellulose and hemicellulose.

Barkcloth

Unlike products made from New Zealand flax, which is only one species from one country, barkcloth is made in many countries with a tropical climate all around the world, and can be made from the inner bark of several species of tree. One of the most popular trees in Oceania is the paper mulberry *Broussonetia papyrifera*, which also supplies the fibre for Japanese Kozo paper, one of the most stable papers known. Other barkcloths are made from species of *Ficus* and *Artocarpus*.

The factors that contribute to the degradation of *P. tenax* are probably also important in the degradation of barkcloth, i.e. acidity, chemically active iron and initial composition. Although the present research into the deterioration of barkcloth has only just started, some interesting observations have already been made. Some barkcloths are dyed or pigmented black, and X-ray fluorescence analysis suggests that some black barkcloths have an iron/polyphenol dye while others have carbon black as the colourant. Deterioration attributable to the iron has been observed. However, there are other samples, which are badly deteriorated and contain no black dye. Non-black degraded samples are generally brownish red in hue. Several dyes are commonly applied to barkcloth, one of these from the bark or root of the candlenut tree (*Aleurites moluccana*) was often used in Oceania and is said to yield a brownish red dye.

A significant piece of research into the degradation of barkcloth was produced by David Erhardt (Erhardt and Firnhaber 1987) who concluded that all the degraded samples examined contained an oil from the nuts of the candlenut tree. The degradation was attributed to the acidity produced upon

oxidation of the oil, but this hypothesis does not explain why degraded barkcloths, which are not black due to iron/polyphenol dye, are invariably red/brown.

Research proposal

The research planned at the British Museum will involve the characterisation of samples of old barkcloth for iron content, pH, presence of dyes, tannins and oils and fibre type. If the characterisation yields apparent causative agents for the deterioration, model systems will be made and subjected to accelerated ageing tests. When the causative agents have been identified conservation measures will be tested.

At present, finding sources of modern raw materials for research is proving difficult. Candlenut oil has been located but not the dye from the candlenut tree. A large sheet of barkcloth is available for research but its fibre type has not yet been identified. Fortunately the British Museum holds books of collected bark-cloths which can be analysed for metal content by a non-destructive method such as X-ray fluorescence; however all the other tests mentioned above involve sampling and cannot be performed on these specimens. It may be necessary to sample barkcloths from other sources to obtain sufficient results to build up a comprehensive picture of barkcloth deterioration.

Some of the results obtained so far are presented below. Figure 3.1 shows a typical X-ray fluorescence spectrum showing the presence of iron in an undyed barkcloth. From these spectra a semi-quantitative measure of iron concentration can be obtained; some of these results obtained so far are shown in Table 3.1. The test for tannins was positive when a 1% ferric ammonium sulphate solution turned the barkcloth black. The results for iron are semi-quantitative and obtained by X-ray fluorescence. A ±50% error may be applied to each result. Some samples were not subjected to all the tests.

Preliminary tests show that samples in poor condition generally contain more iron, more tannin and are more acidic, however, too few results have been obtained to draw definite conclusions.

Table 3.1 Some experimental results for barkcloths in poor and good condition; the results for iron

Test	Good condition	Poor condition
pH	6.2, 4.1, 5.6	3.3, 3.9, 3.6, 3.8, 2.8
Tannin	–	+ + +
Fe (ppm)	200, 200	200, 400, 500, 800 2500, 250, 400

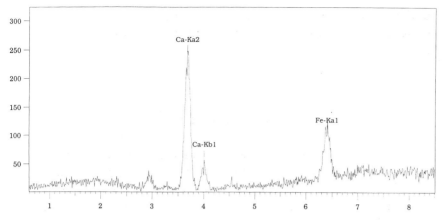

File:
Acquired: 02:15:11 pm on Feb 27, 2001
Real time = 300secs Reference gain = 10.000
Horiz scale: 590 - 8500 eV Vert scale: 324 counts

Figure 3.1 X-ray fluorescence spectrum of barkcloth

Reference

Erhardt, D and Firnhaber, N. (1987) 'The analysis and identification of oils in Hawaiian oiled tapa' in *Recent Advances in the Conservation and Analysis of Artefacts*, J. Black (ed.). London: Archetype Publications, 223–7.

◆4◆

Traditional barkcloth from Papua New Guinea: materials, production and conservation

Rowena Hill

Introduction

The author lived and worked in Papua New Guinea as conservator and ethnobotanist for over six years. It was during this time that she undertook extensive field research in remote villages and rainforest locations documenting traditional manufacturing techniques, and collecting botanical samples and other raw materials. The information in this text forms part of that research.

Barkcloth in Papua New Guinea (PNG) is a hugely ubiquitous material: its function varies from domestic use, e.g. everyday clothing and floor coverings, to ceremonial use such as body ornaments and masks, with increasing elaboration of style. Owing to the differing climates and environmental resources within this region, as well as the tremendous diversity of the cultures of PNG (over 700 linguistic groupings), there are variations in manufacturing techniques from one locality to another (Fig. 4.1).

Traditionally, there was no weaving culture in the PNG region other than for basketry and cordage, and so beaten bark became the primary source of cloth for thousands of years. In the late 19th century, contact with Europeans led to the replacement of barkcloth by imported woven textiles, but there are still many parts of PNG where barkcloth is made today – for both everyday and ceremonial purposes, as well as for the tourist market – as it is cheap to produce, hard wearing, easily renewable and has desirable aesthetic qualities. The degree of decoration also varies according to function and from region to region. Where decoration is employed, it may comprise superficial geometric designs in bold colours, or a plain background colour. The colourants used tend to be applied as paints rather than dyes.

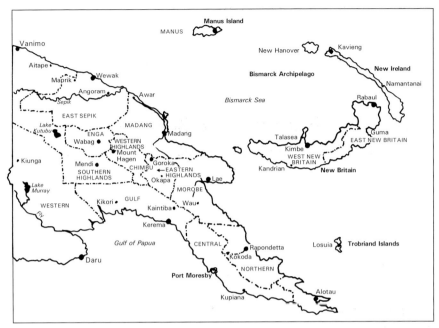

Figure 4.1 Map of Papua New Guinea

Barkcloth from the Melanesian region of the southern Pacific, and in particular PNG, is different from that of the Polynesian region. Its construction is generally coarser and less flexible, even when new, and therefore it poses a slightly different set of conservation problems than the equivalent material from Polynesia. The PNG barkcloth most resembling Polynesian styles is that from Oro (Northern) Province. While working as a conservator at the National Museum of PNG and later at the Queensland Museum, Australia, I was made more aware of the tremendous diversity of this fabric and the apparent inconsistency with which it degraded. I undertook research on the manufacture of barkcloth and other fibrous materials, as well as the dyes and pigments used to colour them, documenting their source materials and the methods of preparation.

Uses of barkcloth

As mentioned above, barkcloth is used throughout PNG even today, but only certain items made from this material are common in museum collections. Traditionally, barkcloth was produced whenever there was a need for an expanse of cloth, such as for clothing and body ornaments (wrappings, straps,

25

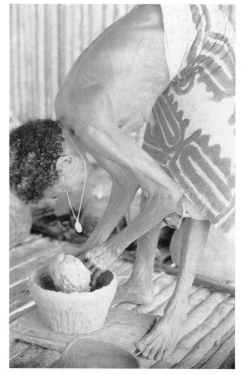

Figure 4.2 Woman potter wearing wrap-around barkcloth skirt, Oreresan, Oro Province (from P. May and M. Tuckson, *The Traditional Pottery of Papua New Guinea*, Crawford House Press, Adelaide, 1982). (*Original photograph by Margaret Tuckson, reproduced by kind permission of the publishers*)

blankets, floor coverings, grave coverings, and the linings or external parts of headdresses and masks). Over much of PNG the climate is hot and humid and there is little need for warm clothing made from fur or skin, so cloth made from bark is ideal for shedding the rain and for adornment.

The most familiar forms of PNG barkcloth are probably the highly decorated, large rectangular pieces from north-east PNG, the Musa River area in Oro Province (Fig. 4.2) made from paper mulberry bark. Such items were worn traditionally by both men and women as aprons or skirts wrapped around the waist, or as capes draped over the shoulders. Some of the highly decorated pieces were specially made for wearing at important ceremonies, such as funerals; others were reserved for gift exchange, for example at betrothals or marriages.

In the slightly cooler Highlands region with its high rainfall, large, thick barkcloth hoods (Fig. 4.3), capes and hats are still made today to protect from rain, as well as for use as ceremonial garments, e.g. back ornaments (Fig. 4.4).

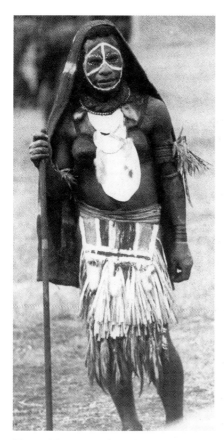

Figure 4.3 Woman from the Southern Highlands wearing barkcloth cape, decorated with white stripes

Figure 4.4 Festival ornament worn at the back, made from barkcloth and dyed with *Coleus* dyes. Gahuku people, Goroka, Eastern Highlands

Such cloth, made from *Ficus* bark, is coarser and darker in colour than coastal examples. It serves its function very well, for being less well beaten means it is thicker and sheds the rain very efficiently. For everyday wear such pieces are undecorated, but may be oiled to increase water resistance. For particular ceremonies, paint of a single colour might be applied as a stripe (Fig. 4.3) or block of colour, such as black charcoal among the Mendi (Southern Highlands) for bride wealth, or white clay among the Gahuku (Eastern Highlands) for funeral attire. In this region too, smaller pieces of barkcloth are coloured with bright red ochre to make the important wrappings for the high status shell money. The Highlands area is also well known for highly decorated wigs which have a base layer of barkcloth onto which Bird of Paradise plumes are mounted (Strathern and Strathern 1971).

Also well known are Baining masks (Fig. 4.5) from New Britain, which consist of a cane frame overlain with large sheets or tubes of white barkcloth, often made from breadfruit tree bark, and coloured with red and black designs. Many other peoples of New Britain, such as the Sulka (Fig. 4.6), Mengen and Nakanai, manufacture huge masks from barkcloth. This tradition is also found today among the Elema people of Orokolo Bay, Gulf province on the mainland (Neich and Prendergrast 1997).

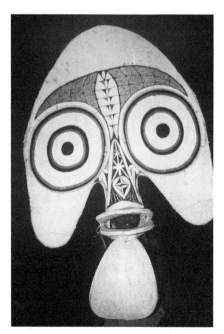

Figure 4.5 Barkcloth mask used for night dances, Baining people, Gaulim Village, East New Britain

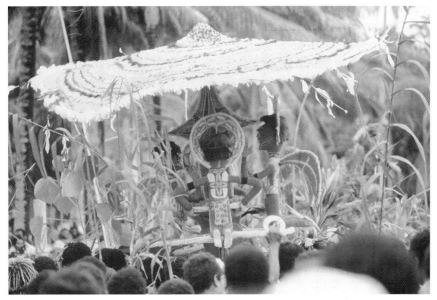

Figure 4.6 Sulka mask from Guma Village, East New Britain – the top surface of the circular 'roof' structure is made of barkcloth to which feathers have been inserted and glued

Materials

The people of PNG are principally subsistence horticulturalists who until recently derived most of their raw materials from their immediate environment. There were also extensive trading networks to obtain raw materials, which were not available locally, such as marine shells from the coast to the Highlands region, acquired as currency items. Much of the territory of PNG is still covered with primary rainforest with grassland in the higher altitudes. Over the millennia the people have been able to exploit the natural flora for use as food, clothing, tools, medicine and architectural structures, selecting the most appropriate species for these various functions. Plant usage depends on the mutual geographical distribution of plant and people and will vary with altitude, soil type, local microclimate and proximity to the sea.

Sources of inner bark

The fibres for barkcloth derive from the inner bark, the secondary phloem, of a variety of tree species. The main sources of PNG barkcloth are: *Ficus* spp. and *Artocarpus* spp. (Moraceae); *Broussonetia papyrifera* (Urticaceae); *Hibiscus*

tiliaceus (Malvaceae). Table 4.1 contains a complete species list and illustrates how the species are used. Many more plant species are employed in the colouring and decoration of the bark (Table 4.2). The people from each individual culture will select for a particular task the best possible plant that happens to grow in their particular locale. It is generally agreed that *Broussonetia papyrifera* makes the 'whitest' barkcloth (Hesse 1982) but this species is limited in its distribution, predominating in coastal locations with sandy, well-drained soils (Barker 1998). In coastal areas, where limestone soils predominate and paper mulberry is scarcer, the breadfruit tree, *Artocarpus altilis*, is the most popular source of inner bark for cloth, also making a whitish cloth. In coastal swampland, where neither species grow, mangrove trees may be selected. Further inland the genus *Ficus* is the next most popular choice, however, the cloth made from this is generally darker in colour than that from paper mulberry or breadfruit being various shades of beige, yellow or grey depending on the species.

Table 4.1 Sources of inner bark, uses and decoration

Plant used	Area (plain text): **people (bold)**	Purpose	Decoration
Artocarpus altilis, Moraceae	New Britain: **Sulka, Baining, Tolai, Mengen.** Manus Island	cloth for masks, belts, aprons	designs painted on in red and black
Barringtonia asiatica, Barringtoneacea	New Britain: **Sulka**	cloth on masks	feathers attached
Broussonetia papyrifera, Urticaceae	Oro Province and many other coastal areas.	men's ceremonial skirts clothing, rain capes, masks	designs in red ochre, mud, charcoal and vegetable dyes
Ficus caulocarpa Moraceae	W. Highlands	rain cape	
Ficus dammaropsis Moraceae	Chimbu, Mt. Hagen	men's head covering	plain, or coated in red ochre
Ficus nodosa Moraceae	New Britain: **Sulka**	pubic cover (*malo*)	designs in black, brown, red and yellow
Ficus robusta Moraceae	Jimi Valley (Powell 1976)	rain cape	none
Ficus trachypison Moraceae	Jimi Valley (Powell 1976)	men's head covering	single colour or no decoration
Ficus wassa Oraceae	Jimi, Mt. Hagen (Powell 1976)	men's head covering	single colour or no decoration
Ficus spp. Moraceae	New Britain: **Baining** Widespread	masks various uses	painted designs in red and black designs painted; plain
Hibiscus tiliaceus, Malvaceae	New Britain: **Sulka**	loin cloths, masks	designs in black, brown, red, yellow and green
Rhizophora sp. Rhizophoraceae	Gulf Province	masks	painted designs

Cultivation, harvesting and de-barking

In the humid coastal areas of mainland New Guinea where the *Broussonetia papyrifera* species thrives well, such as the Musa River delta, Oro Province, the trees are cultivated in small plantations close to the homes of the craftspeople who produce barkcloth (Mosuwadoga 1977). This is so that the trees can be regularly fertilised, de-branched frequently during growth to prevent the formation of knots in the inner bark (Barker 1998), and to allow ready access to them at the time of harvesting.

In this region, the bark is cut from young saplings when they are about two years old – young enough that the fibres are still flexible and old enough that they have sufficient length and strength. Too young and the bark fibres tear easily; too old and they become difficult to beat (Barker 1998; Mosuwadoga 1977). Initially, two cuts are made horizontally using a stone adze, palm knife or steel knife and then the piece of bark is sectioned by two adjoining vertical cuts, after which it is pulled away from the tree. In other areas, such as the Baining region of East New Britain, the trees are not cultivated but harvested wild. The trunk is cut down, then the bark is slit around the girth and rolled

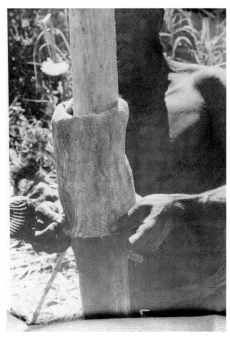

Figure 4.7 Removing bark from young trees for processing into cloth. Baining people, East New Britain (from A. Hesse, *Baining Life and Lore*, Institute of Papua New Guinea Studies, Boroko, PNG, 1982, *reproduced by kind permission of the publishers*)

31

down over itself, like a sock being removed from a leg (Fig. 4.7). This is so that it remains in cylindrical or tubular form and can be pulled over the long, narrow parts of the cane framework, without the need to sew a seam. It is therefore beaten 'double', turning regularly and stretching at intervals to ensure even thickness. In this region slightly older trees of larger girth are used in order to gain a greater width of cloth for covering the wide expanses of mask frame. When cloth of narrow width is required, such as for belts or pubic covers (Fig. 4.8) then small branches may also be used.

Immediately after harvesting and cutting and while still moist, the outer bark (the older secondary phloem) is stripped away using the serrated edge of a suitable cutting tool, traditionally these were large bivalve shells, sharp stones, or a sharp piece of crafted timber. In the Musa River area special, highly ornate knives for this purpose were carved from black palm. The use of such traditional tools has almost died out, having been replaced by imported steel knives.

(a) (b)

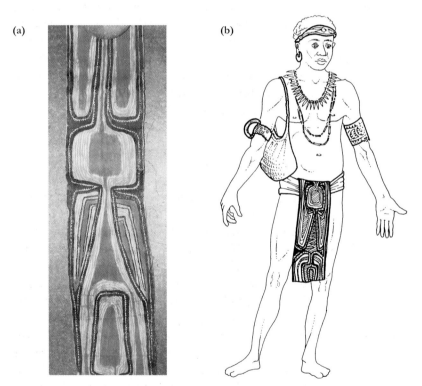

Figure 4.8 Loin cloth made from barkcloth of the style worn traditionally by men of the Sulka and Mengen language groups in East New Britain: (a) barkcloth loin cloth (from the 1930s; Inv. Number Vb8476) from the Speiser Collection (Jacquinot bay), Mengen, East New Britain (Photograph: Rowena Hill, Museum der Kulturen Basel) (b) artist's impression of traditional Sulka man, wearing loincloth (by Robert Brunkie)

Production techniques

Wetting and soaking

In certain areas, the inner bark strips are soaked for a period of a few to several hours until soft, and placed flat over a wide log which will be used as the anvil during beating. The source of water for soaking varies: it may be fresh and flowing, fresh and stagnant, or seawater, e.g. in Bougainville. In areas where adequate supplies of water are difficult to access, as in parts of the Highlands region, the bark is chewed to soften it prior to beating. In such instances, the plant source must not be toxic, and here the genus *Ficus*, many species of which have edible fruit, is used primarily.

In the Oro Province, prolonged soaking or steeping for several hours or longer is preferred since it facilitates beating and produces a stronger and more flexible cloth. The partial fermentation which takes place is actually beneficial. Activity from invading bacteria and fungi, acquired during wetting and soaking, leads to a partial breakdown of the cell wall material helping to liberate the pectins and hemicelluloses which normally cement the cells together *in vivo*. Thus dispersed, some of these binding chemicals get washed away, reducing the overall stiffness of the resultant cloth (Florian *et al.* 1990). Those which remain *in situ* help to thicken the fibres and bond them together in their newly aligned positions thereby strengthening the cloth (Barker 1998).

Beating

Generally, the bark beating process is carried out by women for utilitarian artefacts and by men for ceremonial ones, using the various styles of beater. The beaters may be made from timber, stone or shell, depending on what is locally available and appropriate. If timber, they are carved from durable hardwoods such as *Intsia bijuga*, *Elaeocarpus* sp., *Callophylum inophylum*, and *Diospyrus* spp. (ebony) that can withstand the constant wetting and abrading during the beating. In the Baining and Mengen areas of New Britain, beaters are made from two bivalve shells stuck together with beeswax around the end of a wooden stick, which forms the handle (Fig. 4.9). If the shells fall apart with use, they are easily replaceable. In the Sulka area of New Britain beaters are carved from stone, contemporary ones are limestone (Fig. 4.10) while the older styles are made from basalt. The stone beaters have no handle and are held in the palm of the operator's hand.

The beaters are normally two-sided, one incised and one smooth. The incised side has raised areas that press deep into the wet bark, helping to spread

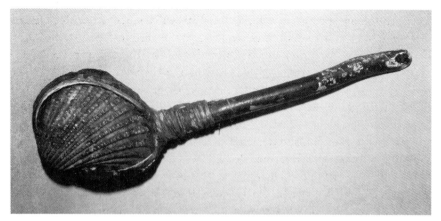

Figure 4.9 Barkcloth beater made from shell, wood and vegetable fibre, Mengen people, East New Britain (*by kind permission of the Linden Museum, Stuttgart*)

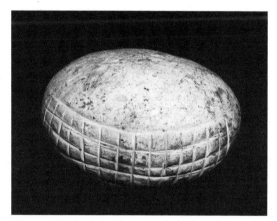

Figure 4.10 Barkcloth beater made from limestone, Sulka people, Guma Village, East New Britain

out the fibres and change their orientation from parallel to random so that they interlink at different angles. It also allows excess water and air to escape during the beating process (Mosuwadoga 1977). The smooth face is used first for flattening and stretching the inner bark, like a rolling pin working damp dough, then later for smoothing and finishing the surface. The result is a strong, flexible sheet comprising a cohesive network of long fibres interlocking at random that can be used flat or stretched and moulded to form different shapes. The incised pattern on the beater is sometimes used in the final stages of beating to impart an attractive texture to the surface of the cloth.

For greater expanses of cloth, separate sheets of beaten barkcloth can be joined together while still wet by overlapping their edges and beating them

together. Joining sections in this way is only possible when the cloth edges are thin and soft and hence this method tends to be used in the coastal regions, where the barkcloth is of a finer texture. For joining together sections of the more coarsely beaten cloth, such as that from the Highlands region, a stitching technique is used after the cloth has dried. In Polynesia, e.g. Tonga, large pieces of cloth are joined when dry using starch-based adhesives, such as cassava (tapioca) paste.

The duration of beating depends on the required width and thickness of the cloth. If the cloth becomes dry during beating it may be re-wetted by further soaking or by sprinkling it with the juices of succulent plants, such as banana leaves, which may also add valuable flexible binding agents such as gums and mucilages. During its manufacture, it can be seen that the barkcloth acquires impurities such as salt, saliva and plant exudates, or tannins and mud from stagnant water.

Drying

The final stage of the manufacturing process is the drying of the cloth. The beaten cloth is spread out and laid flat on the ground in the sun to dry for up to two days, depending on its size. The high ultraviolet (UV) content of the tropical sun bleaches out the dark constituents of the cloth while its heat quickly evaporates the non-bound water, thereby curtailing the growth of micro-organisms. Failure to do this will result in the cloth becoming mouldy when it is brought into the very humid house interior for storage. If the storage period is long term, barkcloths may be brought out of storage from time to time, unfolded and left painted side up in the sun for a few hours to prevent mould growth (Mosuwadoga 1977). Large barkcloths are generally rolled and placed on the roof rafters until required for use. If the house it is kept in is also used for cooking, then the cloth gradually acquires a layer of soot from the open fire. The smoke and heat from the fire help to keep the barkcloth dry and mould-free: aldehydes present in wood smoke have a preservative effect against biodeterioration. It also suggests that some of the dark soiling on barkcloths, which conservators may perceive as 'non-ethnographic' dirt, could actually have been acquired from smoky fires.

Decoration

While much of the barkcloth produced for utilitarian purposes or everyday wear, such as rain capes or wrappings is uncoloured, for ceremonial use, colour

is usually employed. In the Highlands region, the barkcloth used for wrapping important heirlooms, such as shell money, is coated in red ochre which has symbolic qualities beyond that of its colour. Barkcloth used for body ornamentation normally features designs, as well as colour (see Figs 4.3 and 4.4). The designs are a combination of modern themes and traditional motifs (animal and plant representations, mythical ancestors or geographical features such as rivers or lakes). Individual barkcloth makers may have their own established set of design elements to use over and over again, which are the sole property of themselves and their kin. Others may create their own new patterns that are unique to them and may be different on every barkcloth they paint (Fig. 4.11). Contemporary artists also employ designs they see in books or magazines or from product packaging.

The surface of the cloth must be very smooth, like a prepared canvas, in order to facilitate spreading of the paint or dye. For this purpose smooth stones may be used (East New Britain area) or the smooth surface of a wooden beater (Oro Province). Other methods involve pressing under weights: the Maisin women from Oro Province place the newly beaten, and slightly damp, cloths beneath their sleeping mattresses overnight to flatten them, ready for decor-

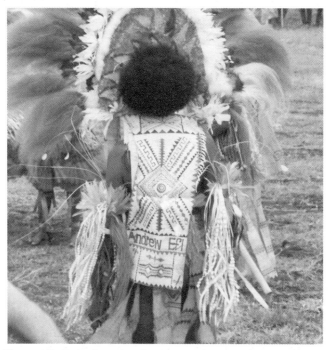

Figure 4.11 Man from Oro Province wearing several different festival decorations made of barkcloth; back ornament, skirt and head ornament

ating the next morning. The large ones are folded first, the fold lines forming the boundaries of panels helping to align the design elements; the painting is then carried out one panel at a time (Barker 1998). Decoration is not always in the form of a paint or stain; barkcloth is sometimes the substrate to which 3-dimensional ornaments, such as feathers, seeds, cowrie shells, or shiny beetle carapaces might be attached by sewing or gluing (see Fig. 4.6).

Colourants

The colourants used on PNG barkcloth include a wide range of mineral pigments and vegetable dyes (see Table 4.2). Red, yellow and brown earth ochres are obtained from naturally formed iron-rich clays, the exact colour depending on the types or quantity of iron oxides present. Black is obtained from charcoal and various resinous or woody plant parts are charred to produce this, e.g. *Canarium polyphylum* sap, coconut husk (Barker 1998) or the nut of *Aleurites moluccana*, candlenut, which is also used in Samoa, for the same purpose (Pritchard 1984). The bark of the candlenut tree is also used as a source of red dye throughout the south-west Pacific and south-east Asia. The inorganic white pigments are made from slaked lime (from burnt coral or shellfish) or white clay. All these dry, inorganic pigments are pulverised then prepared into a paste of suitable consistency by mixing with water or saliva, or with resinous plant saps that function as fixatives.

Vegetable dyes or stains derived from the softer parts of plants, such as fruit (e.g. *Bixa orellana*) or leaves (e.g. *Coleus* sp., Fig. 4.12), are extracted by squeezing manually or masticating, and are usually sufficiently moist to apply directly on to the surface of the cloth using brushes or the fingers. Various colourless plant saps may also be mixed with the dyes to achieve different effects, e.g. the fruit of *Ficus wassa* (Fig. 4.13), used in Eastern Highlands or wild lemon (*Citrus limon*) used in New Britain. These saps have one or more of the following possible functions:

- they are liquid vehicles, rich in gums or latex, which help fix the dye to the fibre and create a surface sheen
- they alter the pH of the dye and modify hue
- they contain antioxidants which help to increase the light-fastness of the dye.

Dyes extracted from wood or bark may need to be steamed or boiled first to extract them. If mordants are used, they are mixed with the dye before application. The mordants in most common use are wood ash (mainly potassium and magnesium oxides) and lime (calcium carbonate/calcium hydroxide).

Table 4.2 Colourants used on PNG barkcloth

Colour	Source	Type/Name	Recipe/Method	Area/Province People (in bold)	Use
Red	mineral pigment (haematite)	red ochre	ground to a paste with water, sap or saliva	Widespread	paint for masks, body ornaments,
	blood from humans	blood	tongue cut – blood wiped on cloth	New Britain: **Baining, Sulka**	red paint on masks
	dye from fruit of *Bixa orellana*	anatto, bixin	seed pod cut open and fruit pulp painted on	Widespread	paint for masks, body ornaments
	dye from bark of *Callicarpa cordata*		bark steamed in bamboo tubes	E. Highlands: **Gahuku**	paint on back ornaments
	dye from leaves *Coleus* sp.	coleus	leaves chewed and mixed with sap of wild lemon	New Britain Eastern Highlands	paint on loincloths dance ornaments
	dye from bark of *Diospyrus* sp.	ebony	bark sap mixed with lime powder	New Britain	paint on masks
	dye from bark of *Glochidion* sp.		bark steamed with wood ash	Highlands	paint on loincloths
	dye from root of *Morinda citrifolia*	Indian mulberry; Turkey red	root bark scraped and mixed with lime powder	**Sulka**, New Britain, Manus Is.	paint for waist belts (*malo*)
	dye from fruit of *Pandanus conoides*	pandanus	fruit crushed and pulp extracted	Highlands and widespread	paint for loincloths
	dye from bark of *Rhizophora* sp.	mangrove	bark crushed and mixed with seawater	New Ireland; Central Province	paint for loincloths
Yellow/ orange	*Curcuma* spp.	turmeric	root crushed and applied direct		paint for loincloths, masks
	dye from bark of *Garcinia* sp.	gamboge	bark mixed with lime	New Britain	paint for loincloths
	dye – *Gardenia gjellerupii*	gardenia	pulp from fruit	Morobe Province	
	dye from bark or leaves of *Mangifera indica*	mango	leaves or bark chewed and mixed with lime	Widespread	paint for masks, loincloths

Colour	Source	Type/Name	Recipe/Method	Area/Province People (in bold)	Use
White	white clay from river banks	mineral constituent – halloysite.	mixed to a paste with water or plant exudate	Widespread	paint for body ornaments
	lime powder – made from burnt coral/bivalve shells	slaked lime – $CaCO_3/CaOH$	lime powder mixed with water or plant sap, e.g. sugar cane juice	New Britain and widespread	
Black	charcoal from a variety of charred plants	charcoal/ carbon	mixed with resinous plant sap or pig fat	Widespread	paint for body ornaments, masks
	iron-rich clays mixed with bark tannins	iron tannate		**Maisin**, Oro **Gogodala**, Western	paint for barkcloth
	carbon deposits from paraffin lamps/stoves	lamp black	mixed with water, saliva or plant sap	Widespread	paint for masks, body ornaments
Blue/purple	dye from leaves of *Coleus scellateroides*	coleus	leaves masticated and mixed with wood ash	Eastern Highlands, Madang	paint for body ornaments
	dye from fruit *Leea indica*		berries crushed and pulp painted on directly	New Britain, **Sulka**	paint for masks, loincloths
	dye from fruit of Melastoma denticulatum		berries crushed	Highlands area (Mendi, Duna)	mainly for face paint and body ornaments.
	dye from fruit of *Timonius* sp.		berries crushed	E. Highlands, **Gahuku**	paint for back ornaments
Brown	tannins accumulating in stagnant water		barkcloth soaked in stagnant pools	Widespread	gives background colour to whole cloth
	brown clay, or mud containing a mixture iron oxides and organic matter	ochre	clay ground to powder applied as paint; cloth buried in mud	Widespread, Oro Province	provides even background colour or stencilled designs
	dye from bark of *Rhizophora* sp.	mangrove	bark steamed with leaves	Central Province	dye for fibre skirts
	dye from *Area catechu*	betelnut	fruit masticated with lime powder	Oro Province	paint for barkcloth

39

Figure 4.12 Red dye made from *Coleus* leaves with paint brush made of *Cordyline* stem

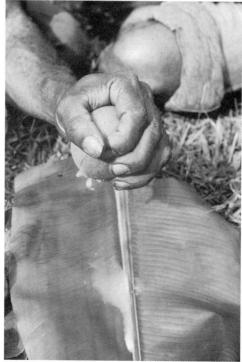

Figure 4.13 Sap from the fruit of *Ficus wassa* (wild fig) being extracted to mix with *Coleus* leaves

In some areas an iron-rich clay is mixed with bark tannins to produce a black stain, a similar chemical process to the production of gall inks.

Depending on the fineness of the design elements required, paint brushes can be selected from a range of fibrous plant parts, such as the splayed ends of cut *Cordyline* stems (Fig. 4.12) or from the fibrous husks of palm nuts, e.g. *Areca catechu* (betelnut). To create rougher, less detailed elements of the design, the colours are often wiped on using the fingers. An even background colour of brown or grey may be achieved by prolonged soaking in muds rich in iron oxides (Mosuwadoga 1977) or by steeping in stagnant pools, rich in tannins.

Deterioration of barkcloth from PNG

The general appearance of degraded barkcloth is fairly well known to conservators. It usually consists of one or more of the following symptoms: a darkening or browning of the cloth fibres; embrittlement of the fibres leading to fracture; fading of the dyes; development of tears along fold lines or fibre separation parallel with the grain direction; lowering of pH – all typical of a gradual breakdown of cellulose. It is not always possible to identify a single cause. The degree of deterioration is dependent on the interaction of chemical constituents and their separate or combined response to environmental agents, such as mechanical stress, light, relative humidity (RH), biological agents and pollutants. We can only begin to understand the deterioration of barkcloth by looking at commonalities in choice of materials, in function, and in types of damage.

Chemical composition

The main constituents of the cell wall materials of inner bark fibres *in vivo* are cellulose, lignin, hemicelluloses and pectin, the exact proportions depending on species, age and growth conditions of the source plant. The ageing and embrittlement of fibres is largely due to cellulose, which makes up 60% or more of the overall content. Lignin, which makes up between about 5% and 30%, is chemically very reactive and is itself prone to photo-oxidation; the by-products of its oxidation are very acidic and catalyse the degradation of cellulose. Several samples of PNG barkcloth were tested for lignin and all tested positive. Separate tests were carried out on areas that looked more obviously light-damaged, i.e. those which were brown and brittle, and all indicated the presence of high levels of lignin.

Tests carried out on cellulosic textile fibres (Tímár-Balázsy 1998) and paper have shown that lignin plays a direct role in cellulose breakdown; the higher the concentration of lignin, the greater the rate of cellulose degradation through oxidation and acid hydrolysis. In the living tissue, some of the hemicelluloses and pectin constituents are cemented to lignin and cellulose, thereby shielding them from other reactive agents. Once fibres are processed (by soaking/beating) some of the hemicelluloses and pectin are removed or detached, leaving the lignin and cellulose more exposed to oxygen, light and other agents with which to react. The types of barkcloth which have undergone the least processing, e.g. Highland barkcloth, are likely to be more chemically stable because much of the cell wall materials of the fibres are still bonded together and are less reactive. They therefore behave more like woody tissues from which they are derived. Highland barkcloths however, may be more susceptible to certain mechanical stresses, such as tension across the grain, because a higher percentage of the fibres are still oriented in a parallel direction (due to less beating).

Lignin is by no means the only chemical influence of cellulose instability. PNG barkcloth fibres also acquire a cocktail of chemical additives during manufacture and use, such as chlorides from seawater, tannins from stagnant pools and bark dyes, organic acids from bacterial action or dye mixtures, aldehydes from smoke, ammonia salts from sweat, lipids from oiling (Erhardt and Firnhaber 1987), all of which can be linked directly or indirectly to the hydrolysis or oxidation of cellulose at high RH levels.

Surface to area-to-volume ratio also plays a part in the rate of deterioration; generally, the thinner the cloth and the more separated the individual cellulose fibrils, the more surface there is to react with the environmental agents.

pH

New pieces of barkcloth tested had average pH values of 5.5–6.8, which correspond closely with pH values of newly cut wood from a range of tropical timbers. None of the pH measurements from the 100-year-old cloths from Oro Province were lower than pH 4, indicating a fairly slow increase in acidity.

Reaction with colourants

On PNG barkcloths I observed no obvious or extreme examples of degradation beneath the paint layers. This may be because the paints used are fairly chemically stable, e.g. earth ochres, or because they are alkaline (many are

mixed with calcium carbonate or wood ash). However, the dark brown coloured areas that were possibly coloured by soaking in tannins, are often highly degraded. Tannins are very acidic and can cause the hydrolysis of cellulose at high RH and in the presence of oxidising agents such as iron (Daniels 1996).

Light damage

The action of light (photo-oxidation) is one the most damaging factors to barkcloth and affects both cellulose and lignin. Unless brand new when acquired by museum collectors, a barkcloth artefact would accrue thousands of lux-hours of damage, as well as high UV exposure during use, owing to solar drying techniques and general use outdoors. The relatively good ageing qualities of Baining barkcloth are no doubt associated with short light-exposure time during use. Such masks were made in secrecy in the dark interiors of men's houses, away from women. Many of them are only used in darkness, at special dance ceremonies held at night and lit only by the glow of a bonfire.

RH and biodeterioration

All barkcloths acquired from PNG will have endured high levels of ambient RH (average 70–90%) particularly if they were stored for lengthy periods in houses lacking air circulation. If cloths were placed on racks above fires, or if they were subjected to regular drying treatments in the sun, the RH fluctuations they endured would be extreme. Those used as clothing – in particular, the rain capes of the Highlands – would have been exposed to constant re-wetting. Within these, the hydrolysis of cellulose would already have begun before acquisition by a museum; there is also the likelihood of dimensional stresses set up by swelling and shrinking. The fibres of such barkcloths may be further weakened by bacterial and fungal activity during the wet phases.

Mechanical stresses

As it is manufactured from thick-walled, secondary phloem fibres with high mechanical strength, barkcloth is naturally durable. It is in the period after these wall materials, in particular the cellulose, have started to break down chemically that mechanical strength is reduced. On PNG barkcloth, the most common form of mechanical damage is fold stress. Fibres become stretched and

distorted along fold lines and either fracture or separate, leading to holes and tears. Not all fold lines are from inappropriate museum storage; during the manufacture and use of barkcloths they may be folded several hundred times in the same place. The larger the item, the more it needed to be folded for storage. Subsequent compression during museum storage will exacerbate existing fold lines and often create new ones. In addition, folded pieces were often rolled for storage, placing even more tension on the existing creases. Conservation procedures involving the relaxing and flattening of barkcloths should try to retain fold lines that can be determined to be of 'ethnographic' origin. Fold damage is less severe on masks, such as Baining masks, for which the barkcloth is stretched on to a cane frame. Instead, tears may develop due to high-tension stresses or from impact damage to the unsupported areas.

Mechanical damage is frequently found along the edges of barkcloths, especially on large, rectangular pieces. The edges are the places that receive most beating during manufacture and they tend to be thinner and distorted, leading to undulations which develop tight creases. Being thin, they are less resistant to wear and this leads to fibre separation. Examples of barkcloth from the Highlands made from *Ficus* although generally more resistant to mechanical stresses, such as surface abrasion and impaction, have a tendency to delaminate along the grain.

Conservation: a case study

Introduction

This section will examine one case study, the conservation of a barkcloth from Oro Province, PNG, held in the MacGregor collection of the Queensland Museum. The conservation strategy employed involved cleaning, deacidification, removal of creases, repair of tears and devising appropriate storage.

Background to the collection

Between 1892 and 1898, the Queensland Museum became the recipient of a large collection of artefacts including 180 barkcloths that had been collected by Sir William MacGregor while Lieutenant-Governor of British New Guinea (Quinnell 2000). Two years before the independence of PNG in 1976, negotiations were held between the Queensland Museum and the National Museum of PNG for the repatriation of part of the MacGregor collection.

An intensive condition survey was carried out in the mid-1980s to assess which pieces could travel safely, and which needed remedial treatment. To date, a total of 93 barkcloths have been repatriated – generally those in better condition. During the survey it was revealed that about 20 of the barkcloths required urgent remedial treatment. The cloth most severely damaged (M2652), and the focus of the study, was made by the Binandere people in the Mambare River area of Oro Province (Figs 4.14 and 4.15).

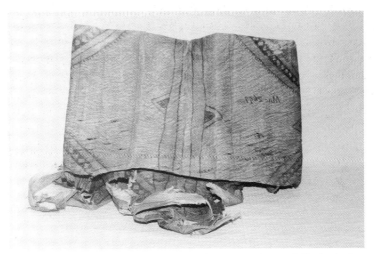

Figure 4.14 Folded bark, severely damaged, from the MacGregor Collection before treatment. (*Courtesy of the Queensland Museum, Brisbane*)

Figure 4.15 Close-up of tear in Barkcloth M2652 showing fragmentation of the fibres, before treatment. (*Courtesy of the Queensland Museum, Brisbane*)

Possible causes of degradation of M2652

Since very little is known about the museum history of this piece, the causes of its degradation can only be surmised. It was received into the main ethnographic collection in 1897 which was then housed in the original museum premises, a Victorian purpose-built sandstone and brick museum. In 1901, the Queensland Museum moved to a larger, even more flamboyant, Victorian brick, former exhibition hall converted to a museum. About 40 of the cloths were on display in the old galleries between 1915 and 1972. Many were displayed folded on a vertical panel which, for over 50 years, was exposed to the morning sun through an unprotected window (Quinnell 1998). Many others were folded and stored in undersized cardboard boxes and, although this had protected them from light damage, they had been subjected to crushing and possible acid-migration from acidic cardboard. The old museum was adjacent to a railway and consequently there was a risk of damage to its collections from sulphur dioxide emissions from passing steam trains. There had been evidence of sooting on some of the other items previously housed there.

Since then, the entire collection of the Queensland Museum has been moved to new, extremely well-designed premises (built in 1985) and now enjoys excellent storage conditions in a pollution-free atmosphere with a very stable microclimate (53%RH + 2%) owing to a constantly monitored and well-maintained air-conditioning plant.

Description of Barkcloth M2652

- Sub-rectangular, measuring 1420mm long by 520mm wide
- Geometric designs in black and red on one side – no evidence of other colours
- Fibre type – probably paper mulberry (no fibre ID carried out, but similar pieces from this area are made from paper mulberry)

Condition summary of Barkcloth M2652, October 1988

- Particulate dirt over both surfaces
- Folded tightly with large tears along and across the fold lines (see Figs 4.14 and 4.15)
- Extremely brittle and fragmentary

- Mid-brown in colour overall but with a large, rectangular patch of lighter shade, suggesting protection from light in this area
- The pH ranged from 4 to 6

Treatment method carried out in October 1988

Relaxing and unfolding

Before the barkcloth could be opened out from its folded state it was relaxed at 95% RH for 24 hours in a polyethylene humidification chamber; the water vapour was supplied by an ultrasonic humidifier. The black and red pigments had been tested previously and were found to be insoluble in water. The cloth was then gently unfolded and laid flat onto two layers of acid-free blotting paper with Plastazote beneath for cushioning. Glass plates lined with acid-free blotting paper were then arranged over the fold lines to partially flatten them; these were left *in situ* for two days. The blotting paper was changed twice daily until dry.

Cleaning

Cleaning was carried out entirely by dry methods as the barkcloth was considered to be too fragile to be wet cleaned. The cloth was cleaned on both sides using a soft sable brush and a low-suction, standard museum vacuum cleaner. The plastic vacuum nozzle was covered with nylon gauze to trap any loosened fibres.

Deacidification

After the cloth was cleaned, spot pH measurements were made using Merck indicator strips, moistened with deionised water, on the dark- and light-coloured areas. Because the barkcloth was very brittle and fairly acidic, it was decided to deacidify it using a 10% solution of methyl magnesium carbonate, which was brushed onto both sides. The alkali treatment appeared to reverse the effects of acidity and the cloth became immediately more flexible, even after drying. It should be mentioned that deacidification was not a standard practice, and that this was the only piece on which it was carried out in an attempt to retard further embrittlement.

Repair

Because the untorn areas were now less brittle and had some residual strength, it was decided to repair only the torn areas by backing them with suitable repair tissue. The barkcloth was placed face down onto silicone-release paper with Plastazote beneath for cushioning. The edges of the tears were further flattened by spraying with deionised water and then weights were placed on these areas. After drying, the cloth remained flat and the tear perimeters could be drawn around to make the shape of the repair patch. This was carried out by placing Melinex (polyester film) over the tear and mapping out the shape of the hole using a permanent marker pen and allowing an extra 1.5cm all round so the repair patch would adhere to undamaged cloth.

Selection of repair tissues

To determine the best choice of repair tissue, the following materials were tested:

- *Japanese tissue paper* (*Kozu-shi*) – 100% paper mulberry fibre, 24gsm. A variety of Japanese tissue papers had been used in previous trials and found not to perform well. Those considered to be sufficiently flexible to be useful were too fine in texture to support the coarse barkcloth and buckled easily. Only one Japanese paper (*Kozu-shi*) was considered strong enough to support the barkcloth.
- *Barkcloth* (contemporary supplies obtained from Tonga made from paper mulberry). Barkcloth is an obvious choice for the repair of barkcloth as it has been used traditionally and is compositionally the most compatible with the artefact. The barkcloth pieces for the conservation repairs were imported from Tonga as PNG supplies were not available.
- *Spun-bonded polyester* (Reemay). In the past, this has been used successfully for the repair of textiles. It is chemically very stable, very flexible and has a 'felted' texture, similar to that of PNG barkcloth.
- *Spun-bonded polypropylene* (commercial name Evolution in Australia). Its main use in ethnographic conservation is for storage (as barrier fabrics and dust covers). It was selected for these tests because it has a 'felted' texture, as does spun-bonded polyester, and it is flexible and chemically very stable. Another advantage is that it is available in neutral brown colours and therefore it does not need to be dyed.

Colour-matching the repair tissues

Small, circular pieces (about 5cm in diameter) were cut from each of the above materials and dyed a neutral brown colour with mixtures of red, blue and yellow Ciba Geigy permanent dyes: Terasil for polyester samples and Solphenol for the Japanese papers and new barkcloth (Table 4.3). Samples of Reemay were also coloured with Winsor & Newton pure pigments in 3% Paraloid B-72 solution in acetone. The polypropylene sample came in a natural brown colour and did not require further colouration.

Selection of the adhesives

Using the adhesives listed below, the test pieces of repair tissue were then attached to new Tongan barkcloth and left near the window of the conservation laboratory for a period of one month:

- tapioca starch
- wheat starch
- methyl cellulose
- hydroxypropyl cellulose (Klucel G).

Tapioca paste had not been used much in barkcloth conservation (prior to 1988) but it was chosen because of its traditional context; it is used very successfully for the traditional repair of holes in barkcloth in Tonga and Fiji. The other adhesives selected have been well documented in conservation treatments.

Test results

The best results were obtained from Samples A and B (Table 4.3) which were, respectively, A: Reemay, coloured with Terasil dyes and B: Reemay, coloured with Winsor & Newton pigments in a Paraloid B-72 medium – both were attached with tapioca starch adhesive. The Tongan barkcloth dyed with Terasil dyes and attached with tapioca starch also behaved well but looked texturally very different from the PNG barkcloth, particularly as it had different fibre orientation. *Kozu-shi* Japanese paper failed the trial because its appearance was too smooth and after drying, when covering large tears, it was generally too stiff and it cockled. This problem was also noted by Häkäri (1995). No other Japanese tissue was considered to be suitable for this purpose.

Table 4.3 Materials tested for the repair of barkcloth

Sample tried Code	Nature of repair		Results obtained after 4 weeks (in 1988)			Results obtained after 10 years (1998)		
	Type of repair tissue	Type of adhesive used	Visual appearance	Adherence quality	Flexibility	Visual appearance	Adherence quality	Flexibility
A	polyester Reemay dyed with Terasil	tapioca starch	very good	very good	very good	very good	very good	very good
B	polyester Reemay coloured with pigments/Paraloid B-72	tapioca starch	very good	very good	very good	very good	very good	very good
object M2562	polyester Reemay (barkcloth deacidified)	tapioca starch	very good	very good	very good	some repairs glossy where adhesive thick	some areas lifting at edges	a little stiff in places
C	polyester Reemay	wheat starch	good	very good	very good	good	good	good
D	polyester Reemay	methyl cellulose	poor – shiny/dark	fairly good	good	poor – shiny/dark	repair had become detached	good
E	polyester Reemay	hydroxypropyl cellulose	poor – shiny/dark	fairly good	good	–	–	–
F	Japanese tissue (*Kozu-shi*)	tapioca starch	poor –	very good	poor – stiff	poor – wrong texture	very good	poor – stiff
G	Japanese tissue (*Kozu-shi*)	wheat starch	poor	very good	poor – stiff	poor – wrong texture	good	poor – stiff
H	Japanese tissue (*Kozu-shi*)	methyl cellulose	poor – wrong texture	good	poor – stiff	poor – wrong texture	some areas lifting	poor – stiff
I	Japanese tissue (*Kozu-shi*)	hydroxypropyl cellulose	poor – wrong texture	good	poor – stiff	poor – wrong texture	–	poor – stiff
J	Tongan barkcloth	tapioca starch	good but wrong texture	very good	very good	good – but wrong texture	some areas lifting	very good
K	Tongan barkcloth	wheat starch	good but wrong texture	very good	good	good – but wrong texture	good	a little stiff
L	Tongan barkcloth	methyl cellulose	good but wrong texture	good	poor – stiff	good – but wrong texture	some areas lifting	poor – stiff
M	Tongan barkcloth	hydroxypropyl cellulose	good but wrong texture	poor – dried shiny	poor – stiff	–	–	–
N	spun-bonded polypropylene	tapioca starch	poor – wrong texture	very good	very good	poor – wrong texture	good	very good
O	spun-bonded polypropylene	methyl cellulose	poor – wrong texture	good	very good	poor – wrong texture	some edges lifting	poor

Ultimately, Sample A was selected for the repair of M2652 as it appeared to be adhering better than the other samples and gave the best appearance visually. It was the most flexible and allowed changes in dimensions in the bark fibres in response to fluctuations in RH, without itself cockling or exerting any stress on them. This property was felt necessary because the ultimate destination of the barkcloth had not yet been decided; if it were to be repatriated to PNG, there would be the risk of fluctuations in RH and vibration during transit. The spun-bonded nature of the fabric, possessing a random fibre orientation, looked visually pleasing and best matched the texture of the coarse barkcloth.

Condition of Barkcloth M2652 a few days after treatment, October 1988 (Figs 4.16 and 4.17)

- Barkcloth lying fairly flat after relaxing and realigning, fold lines still evident
- Barkcloth still fairly stiff but less brittle than before treatment
- pH readings between 7 and 8, after deacidification
- No further fraying: tears and frayed edges supported well by repair tissue
- Repair patches adhering nicely; adhesive does not show from the front
- No obvious colour change to barkcloth after deacidification; dark areas still dark, light areas still light
- No colour transference from repair patch to cloth

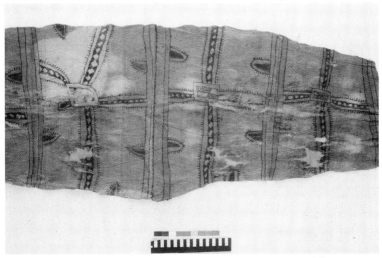

Figure 4.16 Barkcloth M2652, after conservation treatment (upper surface) showing repaired areas. (*Photograph by Bruce Cowell by kind permission of the Queensland Museum, Brisbane*)

Figure 4.17 Detail of repaired area in Barkcloth M2652. (*Courtesy of the Queensland Museum, Brisbane*)

Storage

The treated barkcloth was lain flat in a made-to-measure box of acid-free buffered corrugated cardboard. The base of the box was lined with Dacron (polyester wadding) to provide cushioning and support and this was separated from the barkcloth by acid-free buffered tissue paper. The box was sufficiently deep to allow the storage of two to three similarly sized barkcloths, with the stipulation that they be interleaved with large sheets of acid-free tissue. The box was housed in the ethnographic store, which boasts a very stable climate of 53+/–2% RH.

10-year follow-up condition report on Barkcloth M2652, May 1998 (summary of full report written by Christine Ianna and Amanda Pagliarino, Queensland Museum)

- Initial sharp, acrid odour on opening the lid of storage box – source unknown but being tested; other acidic barkcloths have been stored in same box
- Barkcloth shows minor, low undulations that correspond with old fold lines
- Barkcloth has no suppleness; could be described as stiff
- pH readings 6.5 (in the three locations previously tested)
- Barkcloth shows no new tears and there are no broken or detached fibres

- General unevenness of colour; some light areas, especially a rectangular patch (as before)
- In general the repairs remain attached, although there is some lifting at the edges of some of the patches
- Adhesive slightly glossy in places
- There is limited flexibility in the adhesive
- There is no evidence of colour leaching or bleeding from the dyed patches of Reemay

Comments on the conservation treatment after 1998 condition survey

The condition survey carried out in 1998 raises some interesting and perhaps cautionary considerations, though it must be borne in mind that there is insufficient data to provide any definite conclusions. From this case study, it would appear that deacidification using magnesium bicarbonate has had no long-term effect on the barkcloth; the pH has dropped 0.5 to 1.5 units below the readings taken immediately after deacidification. What will it be in another ten years' time? Although they were interleaved with several sheets of buffered acid-free tissue paper, there is evidence of acid migration from the other barkcloths stored in the same box. Evidently, the tissue paper had not been changed therefore did it act as an acid 'sink'? Better conditions might have been achieved had the barkcloths been boxed individually. The tapioca starch adhesive has lost some of its flexibility and mattness, as well as its adhesive powers in places, though interaction between the alkali and the starch cannot be ruled out. The test piece using non-deacidified barkcloth gave better results when used in conjunction with tapioca starch. The Ciba Geigy Terasol dyes appear to be very stable.

Concluding comments and recommendations

In this paper I have provided new information about the constituents of barkcloths from PNG and it can be seen that there are numerous variables in the overall composition of the bark fibres and impurities, such that no two cloths have identical chemical composition or environmental history. Since much deterioration may already have occurred prior to acquisition, new arrivals into a permanent collections should be systematically condition-checked, and regularly checked thereafter. Only then can it be accurately gauged how much damage has occurred since acquisition.

As conservators of ethnographic material, we should not lose sight of the context and meanings of the objects. What we see as deterioration or damage may actually be part of the history of the piece – mould stains on a rain cape, for example, may help tell the story of its use i.e. its regular wetting and inadequate drying. Fold lines, often considered as museum damage, should be viewed carefully before relaxing them as the fold patterns may be part of the manufacturing process or indicate ethnographic use. Conservators should therefore be encouraged to join curators on 'collecting trips' or undertake their own field research in order to gain first-hand information about ethnographic techniques.

Conservators should be allowed time before treatment to carry out very careful examination, including fibre identification, dye analysis, pH measurement and, where possible, to perform accelerated age tests on treatment materials. The remedial treatments selected should not necessarily duplicate standard approaches but be tailor-made to suit the particular cloth and its environment. Follow-up condition surveys on treated objects should become standard practice. Results should be communicated between our colleagues and us. It is only by concerted effort in our research and honest reviews of previous treatments that we can begin to accumulate data on barkcloth degradation and understand its future conservation requirements.

Acknowledgements

I would like to thank the following people for generously giving their help, expertise and time during various stages of this research project: Soroi Eoe, Barry Craig, Chris Isaac, Francis Bafmatuk, National Museum of Papua New Guinea; Paul Anis, Guma Village, East New Britain; David Frodin, University Herbarium, Port Moresby; Bruce Cowell, Christine Ianna, Amanda Pagliarino, Michael Quinnell, Bruce Cowell and Robert Brunkie, Queensland Museum; John Barker, University of British Columbia.

References

Barker, J. (1998) *Manufacture of Maisin Barkcloth*. Unpublished report. University of British Columbia, Vancouver

Daniels, V. (1996) 'Maori black mud dyeing of *Phormium tenax*', *Dyes in History and Archaeology*, 14. York: Textile Research Associates, 9–13.

Erhardt, D and Firnhaber, N. (1987) 'The analysis and identification of oils in Hawaiian oiled tapa', in *Recent Advances in the Conservation and Analysis of Artifacts*, J. Black (ed.) London: Archetype Publications, 223–8.

Florian, M-L. E., Kronkright, D. P. and Norton, R. E. (1990) *The Conservation of Artifacts made from Plant Materials*. Marina del Ray, Calif.: Getty Conservation Institute, 20–24, 102–104, 148–51.

Häkäri, V. (1995) 'The conservation of tapa using tapioca paste', in *Starch and Other Adhesives for Use in Textile Conservation*, P. Cruickshank and Z. Tinker (eds). London: UKIC, Textile Section, 14–19.

Hesse, A. (1982) *Baining Life and Lore*. Boroko, PNG: Institute of Papua New Guinea Studies, 45–7.

Mosuwadoga, G. (1977) *Traditional Techniques and Values in the Lower Musa River*. Waigani, PNG: Trustees of the National Museum and Art Gallery, 4–13.

Neich, R. and Prendergrast, M. (1997) *Traditional Tapa Textiles of the Pacific*. London: Thames and Hudson Ltd., 133–54.

Powell, J. (1976) 'Ethnobotany', in *New Guinea Vegetation*, J. Paijmans (ed.). Canberra: Commonwealth Scientific & Industrial Research Organisation (CSIRO) in association with Australian National University Press, 168–70.

Pritchard, M. (1984) *Saipo: Bark Cloth Art of Samoa*. Pago Pago: American Samoa Council on Culture, Arts & Humanities, Special Publication No. 1, American Samoa, 1–15.

Quinnell, M. (1998) Personal communication.

Quinnell, M. (2000) 'Before it has become too late: the making and repatriation of Sir William MacGregor's official collection from British New Guinea', in *Hunting the Gatherers: Ethnographic Collectors, Agents and Agency in Melanesia, 1870s–1930s*, M. O'Hanlon and R. Welsch (eds). Oxford: Berghahn, 81–102.

Strathern, A. and Strathern, M. (1971) *Self-decoration in Mount Hagen*. London: Gerald Duckworth & Co., 87–8.

Tímár-Balázsy, A. (1998) 'Fibres', in *Chemical Principles of Textile Conservation*, A. Tímár-Balázsy and D. Eastop (eds). Oxford: Butterworth-Heinemann, 19–36.

Bibliography

Bell, L. (1988) *Papyrus, Tapa, Amate & Rice Paper: Papermaking in Africa, the Pacific, Latin America and Southeast Asia*. McMinnville, Oregon: Liliaceae Press, 41–53.

◆5◆

The research and proposed conservation of the barkcloth elements of a Tahitian chief mourner's costume

Morwena Stephens

Introduction

Tahitian chief mourners' costumes were collected at the end of the 18th century by the early European visitors to Polynesia during, for example the second Cook voyage, 1772–1774, and Bligh's breadfruit voyages in 1789 and 1792. The costumes are thought to have been worn by a priest or a close relative of a high-ranking deceased person. The chief mourner, accompanied by a group of individuals, body-painted with charcoal, also carried a set of pearl shell clappers and a stick armed with sharks' teeth, which he was said to use to attack people who had not managed to flee his path. Accounts of the procession are summarised in Cranstone and Gowers (1968) and Norton (1984). The costumes appear to have been highly prized by the Europeans and became a valuable trading commodity for the Tahitians for whom they were very high status items. Although many of these costumes may be lost, several complete and incomplete costumes can be found in museums across the world including the Bishop Museum, Honolulu, the British Museum, London, the Pitt Rivers Museum, Oxford and museums in Göttingen and Berne (Kaeppler 1978) and Perth, Scotland (Idiens 1980).

Using the example at the Royal Albert Memorial Museum (RAMM), Exeter, the one at the British Museum (Cranstone and Gowers 1968), and those at the Pitt Rivers Museum (1886) and the Bishop Museum (Norton 1984), an attempt is made to show what might be considered to be the distinctive components, as well as the frequently associated components of the costumes before focusing on the barkcloth elements of the costume in Exeter.

Component parts

Distinctive parts of the dress include the shell and feather face mask (Fig. 5.1) and the crescent-shaped wooden breastplate decorated with pearl shells and feathers (Fig. 5.2). A shell apron, made up of pierced rectangular pieces of shell, is attached to the breastplate, although in some cases this has become separated from the wooden board as in Saffron Walden Museum (Pole 1987) where only the shell apron remains and in Perth where only the crescent board is retained (Murray 1992).

Another integral element is the coconut shell apron, a narrow rectangle of barkcloth with a slit for the head and decorated with rows of flat coconut shell beads (Fig. 5.3). This is sometimes backed or padded, at the top, with a piece of fine woven matting (such as in the British Museum, Pitt Rivers Museum and Bishop Museum examples) or, as is the Exeter apron, padded with layers of different types of barkcloth between the outer and lining barkcloths (Fig. 5.4).

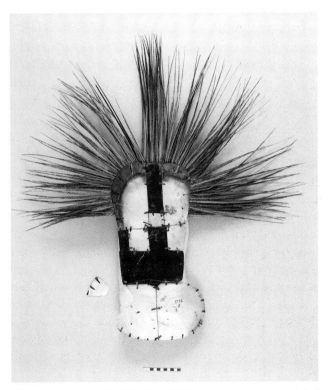

Figure 5.1 Face mask of Tahitian chief mourner's costume: pearl shell, turtle shell, coir(?) fibre and feathers (*Royal Albert Memorial Museum, Exeter*)

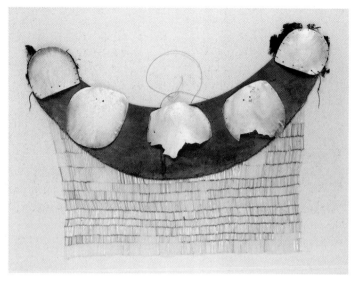

Figure 5.2 Breastplate of Tahitian chief mourner's costume: crescent-shaped wooden panel with pearl shells, coir (?) fibre and feathers. The pearl shell apron comprises cut rectangles of pearl shell tied with vegetable fibre. Missing rectangles were replaced by Perspex during a previous conservation treatment (*Royal Albert Memorial Museum, Exeter*)

BOTTOM TOP

Figure 5.3 Coconut shell apron of Tahitian chief mourner's costume: barkcloths, coconut shell, vegetable fibre cord (*Royal Albert Memorial Museum, Exeter*)

Another key component is the feather cloak of black (chicken, frigate or pigeon) feathers secured on an open net construction of fibres, which is often associated with hanging feather pendants as on the Bishop Museum (Kaeppler 1978) and British Museum (d'Alleva 1995) examples. Sadly, the feather cape of the RAMM costume is missing, recorded as having been discarded by the turn of the century 'on account of moth' (RAMM 1872).

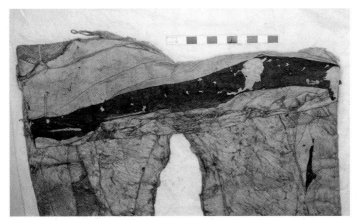

Figure 5.4 Detail of the top of the reverse of the coconut shell apron of Tahitian chief mourner's costume showing the different barkcloths in the padding layers (*Royal Albert Memorial Museum, Exeter*)

Frequently a barkcloth cape of appliquéd/adhered horizontal bands, often with a triangular design towards the top, is also incorporated, as in the Bishop Museum (Norton 1984), Pitt Rivers and British Museum (d'Alleva 1995) examples and seen in some contemporary watercolours (MacLean 1972).

It has been argued by d'Alleva (1995) that the appliquéd barkcloth component of the Exeter costume (Fig. 5.5) was originally the cape and it does exhibit some creasing patterns consistent with having been worn/mounted as such. This garment was however, displayed as a skirt when exhibited as part of the costume in the Vancouver Centennial Museum 1978 exhibition. The fold and string channel are modern as demonstrated by the thread used and the continuation of the grey sooty soiling under the fold. The top edge is convex rather than concave, making it perhaps unsuitable for wear as a cape unless the cape was designed to go high around the neck. Additionally, the pattern is discontinued along the whole width of the top, unlike other examples of capes in which the pattern continues along the lateral edges where it would have been visible (Fig. 5.6 shows a Tahitian cape from the RAMM Collection). Furthermore, some 18th-century illustrations appear to incorporate patterned skirts, such as the one published in MacLean (1972). However further consultation (d'Alleva 1997) suggests the appliquéd barkcloth in the Exeter costume (Fig. 5.5) is a cape.

The costumes are generally accompanied by a set of clappers consisting of two large pearl shells attached to each other by barkcloth (Fig. 5.7). Further elements frequently associated with chief mourners' costumes are rope bundles (Fig. 5.8) and a head covering, either in the form of a barkcloth 'turban', as in the Pitt Rivers Museum and British Museum dresses or a hat (Fig. 5.9), as in Exeter and Honolulu.

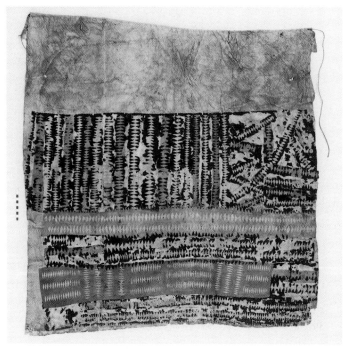

Figure 5.5 Appliquéd barkcloth cape of Tahitian chief mourner's costume: the black uppermost layer of barkcloth is fragmentary and has suffered much loss rendering the design difficult to read (*Royal Albert Memorial Museum, Exeter*)

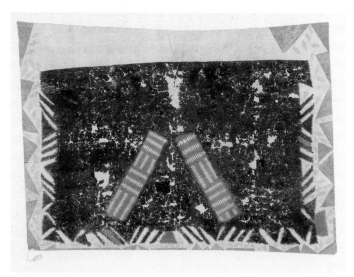

Figure 5.6 A barkcloth cape collected during the same Bligh voyage. Although there is no decoration in the centre of the top edge, the pattern continues along the lateral edges to the top of the cloth (*Royal Albert Memorial Museum, Exeter*)

Figure 5.7 Pearl shell clappers of Tahitian chief mourner's costume tied with barkcloth (*Royal Albert Memorial Museum, Exeter*)

Figure 5.8 Rope bundles with core of plant, stem split in two and twisted together, wrapped in minimally processed barkcloth and bound with flat plant material coloured purple/brown on the outer surface. Part of Tahitian chief mourner's costume (*Royal Albert Memorial Museum, Exeter*)

Figure 5.9 Hat of Tahitian chief mourner's costume: woven plant material with strip of fine white barkcloth wrapped around the upper part (*Royal Albert Memorial Museum, Exeter*)

Finally, there are the barkcloth undergarments in which there is some variability. The costumes in London and Oxford have poncho-style garments, rectangles of barkcloth with slits for the head, with the one in the Pitt Rivers Museum being roughly knee length and that in London full length; 18th-century illustrations (reproduced e.g. in Kaeppler (1978) and in Barrow (1979)) show similar variability.

Provenance of the Exeter costume

Research by John Allen (1995) and Anne d'Alleva (1995) suggest that it is most likely that the Tahitian chief mourner's costume was collected by Lieutenant (later Captain) Bond, who had strong Devon connections. He accompanied his uncle, Captain Bligh, on his second voyage to the Pacific. Bond donated his collection of 19 specimens to the Devon and Exeter Institution in the early 19th century, from where they were transferred to the Royal Albert Memorial Museum by 1868 (Allen 1995).

The barkcloth elements of the costume

As well as the cape there is barkcloth in the coconut shell apron, the hat trimming, the ropes and the shell clappers. It was considered most useful to approach the different barkcloth elements using a list of categories prepared by Sherry Doyal for the condition survey work (see Chapter 2, Appendix 1). I have simplified and tabulated the categories into two tables (5.1 and 5.2), one for description and the other for condition. For the purpose of this paper I will concentrate on four of the types of barkcloth present:

1 the ground of the cape, the ground and lining of the apron
2 the fine white tapa of the cape, apron padding and especially the hat
3 the dark brown/black tapa of the cape and the apron padding
4 the relatively unprocessed barkcloth, which binds the clappers and the outer surface of the ropes.

The other coloured barkcloths, appliquéd onto the cape or incorporated in the padding of the apron, are not considered here.

Table 5.1 Description of barkcloths

Barkcloth element	Flexibility	Thickness	Grain direction	Beater marks per 10mm	Surface decoration	Finish of margins
Cape						
ground	variable	variable	vertical	2.5	appliqué	cut
cream appliqué	papery/stiff	even, thin	vertical?	11	uncoloured?	cut
black appliqué	stiff	even, thin	vertical	11	stained/dyed	cut incl. dentate
Apron						
ground	variable	thick	vertical	3.5, 4.5, 5.5	uncoloured stitched coconut shell beads	cut
lining	quite flexible	thick	vertical	2.7	uncoloured	cut and raw
white padding	flexible	even, thin	vertical	10	uncoloured/ bleached?	cut
black padding	stiff	even, thin	horizontal	11	stained/dyed	cut
Hat strip	stiff, crisp	even, thin	vertical	12	bleached?/ uncoloured	cut
Rope covering	flexible	thick	vertical	not visible	uncoloured/ bleached?	cut?
Clapper tie	flexible	variable	vertical	not visible	uncoloured/ bleached?	cut/ raw?

Table 5.2 Condition of barkcloths

Bark cloth element	Structural damage	Disfigurement	Chemical	Biological	Accretions	Previous repairs
Cape						
ground	holes, delamination thinning, distortion, loss, creasing	discolouration and staining	yes and corrosion	insect	soot, iron corrosion	reattachment of appliqué in 1978 with Beva
cream appliqué	insect holes and distortion	discolouration and staining	lower edge	insect	soot and adhesives	reattached?
black appliqué	severe loss, fragmentary	white and shiny accretions	severe and generalised	no	shiny adhesive	reattached
Apron						
ground	delamination, creasing	sticker, brown stain	some	insect	soot, iron corrosion	beads reattached with nylon filament
lining	delamination, creasing	yellow stain	some	insect	soot	none
white padding	creasing	discolouration	some	insect	soot	none
black padding	loss, fragmentary, creased	white discolouration	severe, brittle	insect	soot	none
Hat strip	creased, frayed end	orange stains	minimal	no	soot	none
Rope covering	parts loose, vertical splits	discolouration	woody + associated with woody residues	insect?	soot and encrustation	none
Clapper tie	delamination and splits	orange stains	yes	no	soot	nylon filament addition

Cape ground and apron ground and lining

The cape and apron ground and the apron lining are quite flexible, thick and made from relatively unprocessed barkcloth, with only 2.5–5.5 beater marks per 10mm. Kooijman (1972) describes how fine barkcloth is achieved by first beating with wide grooved beaters before beating with increasingly fine grooved beater-faces. The grain direction of the fibres appears to be vertical to the garment with no varying beater direction. These barkcloths appear to be uncoloured although it has been questioned whether the cape ground was initially yellow (d'Alleva 1995). Spot colour bleed tests, with deionised water, show movement of grey/brown colour, which may well be water-soluble soiling and degradation products or, perhaps, dye or colouring. The main condition problem, which relates to their barkcloth type rather than their function, is delamination and thinning. Although there are insect holes, they seem to be exit holes rather than evidence of grazing as seen on some of the lighter and finer barkcloths. Condition problems relating to their function in garment structure include creasing and distortion relating to display mounting, and to pinning with pins/nails that have since corroded *in situ*.

White and cream barkcloths on the hat, apron and cape

These barkcloths are quite flexible but have a papery quality to them. They are very even and thin with regular fine beater marks of 10–12/10mm and the grain direction is generally vertical to the cut of the piece. They are markedly disfigured by the grey sooty soiling and some orange-brown staining especially on the hat, which may be foxing (i.e. of fungal origin). The light barkcloth, appliquéd along the bottom of the cape, has suffered severe insect grazing typical of the sort caused by silverfish on paper. Other damage is more related to the cloth's inclusion in the garment, for instance creasing and distortion. One end of the otherwise very white and crisp trimming on the hat is severely soiled and fraying. The extent of processing required to achieve this fine barkcloth may mean that the fibres are strongly bound together minimising delamination (although this may also be because the structure is so thin). It may also mean that the cellulose is more purified and possibly even broken down by the extra fermentation in the manufacturing process (Kooijman 1972), which might make it more digestible for insects.

65

Dark brown/black barkcloth on the cape and in the apron padding

This thin even barkcloth, with 11 beater marks/10mm, is very stiff, probably due to degradation, which makes it impossible to know whether it was like this when newly manufactured. According to Kooijman (1972) in Tahiti, the black colour was achieved by burying the cloth in dark marshy 'mountain plantain' soil. He also states that the brown barkcloth was piece-dyed by immersion in dyes from the bark of either *toa* or *aito* (*Casuarina equisetifolia*) or of the candlenut tree. Generally it has been assumed by conservators that the marshy soil, at least, must have a high iron content, which consequently led to a type of degradation often seen in iron-mordanted cellulose textiles, i.e. embrittlement and fragmentation. The presence of iron was confirmed by Vincent Daniels at the British Museum (see Chapter 3). Samples of lighter coloured and undyed barkcloth from the same costume have not yet been tested so it is not possible to confirm that the iron content of the black barkcloth is unusually high and therefore may have led to its accelerated deterioration.

The black appliqué of the cape is recorded as having been rejoined in Vancouver in 1978 using Beva 371 (poly(ethylene/vinyl acetate) (Waterman 1978). Areas of the now stiffened and slightly shiny black appliqué fluoresced green under ultraviolet (UV) radiation in a way similar to new Beva 371 film.

The barkcloth on the clappers and on the ropes

Both the rope covering and the clapper tie are of quite flexible, soft, whitish barkcloth with no obvious beater marks. They appear to have been only minimally processed and the grain direction runs vertically along their length.

Figure 5.10 Detail showing the effect of surface cleaning on the ropes. The lower length has been cleaned by brushing into a vacuum while the upper length is uncleaned. Note also the damage to the barkcloth, which has become loose after loss of the binding material

Their main problem appears to be splitting along the grain direction, especially where in those areas where they have come loose (Fig. 5.10). They are heavily soiled with grey, loose, particulate matter and the clapper tie has some orange stains similar to those on the hat barkcloth. Some of the rope covering is still associated with woody material, which appears to exhibit accelerated chemical degradation.

Proposed treatment

The barkcloth elements of the costume are being surface cleaned by brushing into a vacuum to remove as much as possible of the sooty grey soiling or 'museum dirt'. Wet cleaning or solvent cleaning has been ruled out because of the fugitive dyes on the coloured pieces and the composite nature of the objects of which the undyed barkcloths are a part. Additionally, there is little evidence that wet cleaning fragile cellulosics alone is sufficient to remove all acidity (Peacock 1983; Hackney and Ernst 1994). Organic solvents are generally ineffective in removing the polar soiling associated with acidity. In surface tests, the pH of much of the barkcloth was measured as 4.

There is an argument for deacidifying the barkcloth where practically possible as the costume is going on permanent display. It would be necessary to use a non-aqueous application method to avoid colouring and soil migration. As much of the barkcloth, i.e. all that is not dyed black/dark brown, remains flexible and the long-term implications of adding buffering agents to the fibres are not fully known, deacidification is unlikely to be carried out during this conservation treatment.

Creasing and some distortion will be lessened by humidification, such as on the apron edges and around the neck slit using Goretex (semi-permeable membrane) sandwich methods. The whole hat, which is flattened, will be humidified in a humidity chamber. Delaminated areas will be humidified where necessary before being rejoined to the main cloth.

The dark brown/black barkcloth needs full support where it is exposed on the apron. On the cape it is generally consolidated by its previous adhesive treatment of the late 1970s. Some of the lighter coloured appliquéd bands will also need to be rejoined to the cape ground where they are lifting at the edges. The thinned areas of the cape ground should be given a support in a flexible, dyed material. Possibilities considered are nylon gossamer and Japanese paper.

The 16 lengths of rope have been treated. They were surface cleaned by brushing along their length (in both directions and on both sides) towards a vacuum (Fig. 5.11). Many areas required localised support where the outer

Figure 5.11 Detail showing repair of the ropes in progress. Lightweight Japanese tissue was coloured with acrylic paints (over thick Holytex to absorb excess acrylic binding media) and attached using methyl cellulose, 5% in deionised water further diluted to 2% with industrial methylated spirits (IMS: 95% ethanol, 5% methanol)

purple/brown binding material had become embrittled and been lost leaving the barkcloth loose. The loose barkcloth has a tendency to split along its length corresponding to the grain direction of the minimally processed inner bark. The loose barkcloth was re-secured with patches of coloured Japanese paper (Fig. 5.12) attached with methyl cellulose (5% in deionised water further diluted to 2% with industrial methylated spirits (IMS: 95% ethanol, 5% methanol)). Where the loose barkcloth corresponded to a stiffened or 'set' bend in the rope, the area was locally humidified in a sandwich of Melinex, wet blotting paper and Sympatex (a vapour-permeable membrane with a polyester wadding backing). Other deformations will be left until it is known exactly how the ropes will be assembled around the upper part of the costume.

Mounting will be a very important part of the preparation for redisplay. Each part of the costume should have an individual mount that can be attached to a central rod, which will stand vertically in the case. The approach to the mounting therefore draws on that followed by Norton (1984); Figure 5.12 shows the basic structure of the mount. Parker (1997) looked at ways of mounting Indonesian costume as worn, rather than as flat textiles, while aiming to minimise unnecessary stress to the garment. For instance she lined the top of the waist with polyester felt to reduce creasing when the skirt was pleated and gathered at the waist, and replaced pins with broad bands which distributed the stress on the object. It is hoped that a similar approach can be implemented with the barkcloth cape by, for instance, placing a layer of polyester felt behind it to give support in its vertical display.

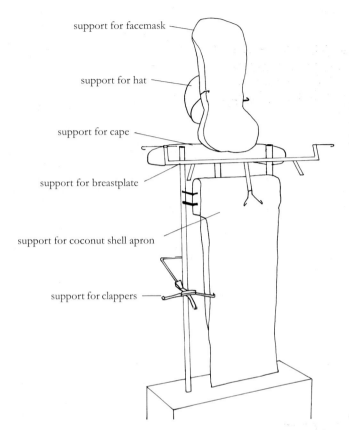

support for facemask

support for hat

support for cape

support for breastplate

support for coconut shell apron

support for clappers

Figure 5.12 Diagram to illustrate the structure of the proposed mount. Each element can be attached individually and will be designed to give maximum support for each part of the costume. When assembled, the mounted costume should however, give an accurate impression of the costume 'as worn'. If the appliquéd barkcloth is a cape, an element of the support will be designed to fit the mount accordingly

As in Norton's (1984) remounting of the coconut shell apron, no attempt will be made to put it over the central pole 'as worn' but rather it should be folded over a padded horizontal bar in such a way as to give the correct overall appearance, but without the unnecessary and distorting stress otherwise caused.

References

Allen, J. (1995) 'Artefacts at Exeter City Museums from Bligh's second voyage to Tahiti', *Pacific Arts* **11 & 12**, 43–7.

Barrow, T. (1979) *Art of Tahiti*. London: Thames and Hudson.

Cranstone, B. A. L. and Gowers, H. J. (1968) 'The Tahitian mourner's dress: a discovery and a description', *British Museum Quarterly* **32**, 138–44.

d'Alleva, A. (1995) 'Change and continuity in decorated Tahitian barkcloth from Bligh's second breadfruit voyage, 1791–1793', *Pacific Arts* **11 & 12**, 29–42.

d'Alleva, A. E. (1997) *Shaping the Body Politic: Gender, Status and Power in the Art of Eighteenth-century Tahiti and the Society Islands*. Unpublished doctoral thesis, Columbia University, 214.

Hackney, S and Ernst, T. (1994) 'The applicability of alkaline reserves to painting canvases', in *Preventive Conservation Practice, Theory and Research*, A. Roy and P. Smith (eds), International Institute for Conservation (IIC) Preprints of the Ottawa Congress, 12–16 September 1994. London: IIC, 223–7.

Idiens, D. (1980) *Catalogue of the Ethnographic Collection: Oceania, America, Africa*. Perth: Perth Museum and Art Gallery.

Kaeppler, A. L. (1978) 'Artificial Curiosities: an Exposition of Native Manufactures Collected on the Three Pacific Voyages of Captain James Cook, R.N.', *Bernice P. Bishop Museum Special Publication* 65. Honolulu: Bishop Museum Press.

Kooijman, S. (1972) 'Tapa in Polynesia', *Bernice P. Bishop Museum Bulletin*, 234. Honolulu: Bishop Museum Press.

MacLean, A. (1972) *Captain Cook*. London: Collins.

Murray, W. (1992) 'Conservation of a Tahitian mourner's costume', *Scottish Museum News* **8**(1), 6–7.

Norton, R. E. (1984) 'The stabilization, mounting and packing of a Tahitian mourner's costume', *AICCM Bulletin* **10**(1), 35–53.

Parker, S. (1997) *The Display of Indonesian Costume as Worn: Evaluating Conservation Needs and Compromises*. Unpublished Report, Textile Conservation Centre, London.

Peacock, E. E. (1983) 'De-acidification of degraded linen', *Studies in Conservation* **28**, 8–14.

Pitt Rivers Museum (1886) Curatorial/accession records, 1886.1.1637.

Pole, L. (1987) *Worlds of Man: Ethnography at the Saffron Walden Museum*. Saffron Walden: Saffron Walden Museum.

Royal Albert Memorial Museum (1872) *The Ethnography Register*.

Waterman, W. R. (1978) *Condition Record*. Vancouver, BC: Conservation Division, Centennial Museum.

Note

At the time the project was undertaken, Morwena Stephens was a Museums and Galleries Commission Intern in Ethnographic Conservation at the Royal Albert Memorial Museum, Exeter.

◆6◆

The deacidification and conservation of a Samoan tapa at the Manchester Museum

Emily Johnson

Introduction

This paper describes the conservation of a particular tapa (most probably Samoan) from the Manchester Museum collection (Fig. 6.1). This tapa was found to be in an advanced state of deterioration, atypical of the collection's general condition. Like most of the collection, this fragile tapa was folded in a Polythene bag. The surface pH of the fragile cloth was found to be 2–3, and it was quite dirty and very brittle, especially around the edges. This paper discusses the planning and implementation of a highly interventive treatment,

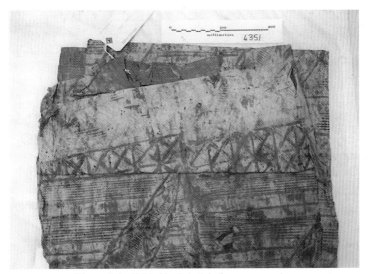

Figure 6.1 Folded barkcloth before conservation

designed to slow or halt acidic deterioration and thus extend the life span of the cloth. As part of the project, colour changes in the tapa and the dyes, caused by the treatment and changes in pH, were measured.

Description and condition of the tapa

The origin of the tapa cloth is not well documented in the museum records. A label attached to the cloth merely suggested that it is Fijian or Samoan however, the design style and the tapa's quite coarse quality suggest that the latter is more likely. This was supported by P. Gathercole (1996), who also suggested a Tongan origin as the design styles of Tonga and Samoa are similar. However, the Bishop Museum (Rose *et al.* 1988) makes a special mention of Samoan tapa noting that it is especially prone to acidic deterioration (as displayed by this particular tapa) due to a local dye made from *Bishofia javanica*. It was interesting to note that all the detached tapa fragments were saturated right through with a red-brown dye. Had the resources had been available, dye analysis would have been very helpful in confirming the cloth's origin as each Polynesian island used dyes made from local plants.

The tapa is roughly rectangular averaging 189cm × 105cm in size. It has a plain red-brown border along three of the sides that probably indicates that the cloth was once part of a larger piece. The rest of the design consists of squares, lines and circles and arcs. Painted freehand (not printed), the design seems to have been worked in the red-brown dye first and then over-painted with black- and brown-coloured dyes. This is clearly visible on the underside, where the red-brown outline has soaked right through the cloth. Some of the black lines have also been over-painted with a 'varnish' giving a glossy finish. The tapa was undoubtedly manufactured from a single piece and there was no evidence of any joins and no signs of any lamination. By comparison with the literature, the colour and texture of the tapa might suggest that it is made from paper mulberry (*Broussonetia papyrifera*), but this has not been confirmed by fibre analysis. There is also a row of small, regularly spaced holes about 10cm from one side perhaps indicating that, in the past, the cloth may have been stitched or pinned to something. The tapa pH was low (measured using BDH/Merck narrow range and universal indicator paper), around pH 2–3 and the edges were brittle. Small fragments of the tapa were found all over the cloth and in the bag.

Preliminary conservation: unfolding, relaxing and dry cleaning

To obtain a more complete picture of the barkcloth's condition and design, it was first relaxed and unfolded in a humidity tent (using the method described in Chapter 8). The cloth was found to be covered with the characteristic Manchester black dust, particularly on those areas originally on the outer side of the folded tapa. The tapa was then given a basic clean. Dry cleaning with a soft brush and an air jet was not very effective and tended to dislodge surface fibres. Dabbing with a rubber latex sponge was much more successful and removed a considerable amount of surface dirt with less abrasion. After the preliminary conservation, the cloth looked cleaner, but the full extent of the deterioration had also become clear. The pH was found to vary between 2 and 3 over the entire surface of the cloth and there were extended areas of smaller losses and cracks, especially where the cloth had been folded and along the shorter sides. It was clear that the cloth, in its present state, was neither sufficiently strong nor flexible to be stored rolled on a cardboard tube. The tapa required additional support, perhaps a lining, but, without addressing the problem of acidity, it would not survive much longer. The low pH encourages degradation of the cellulose fibres by the autocatalytic reaction of acid. At present, the easiest way of slowing or halting this reaction is to raise the pH, thus removing the reactive H^+ ions.

Planning the deacidification treatment

The literature review

There was no procedure for the treatment of acidic barkcloths at the Manchester Museum and therefore a literature review was undertaken to establish if such conservation treatments had been undertaken on Samoan tapas. The review was undertaken from the point of view of a conservator/chemist with no particular bias towards any particular branch of conservation. Textile, paper, ethnographic and tapa-specific articles and books were consulted. From the search, it was clear in terms of conservation that tapa is a little researched material. The research that has been undertaken has not been particularly systematic, often does not take into account the wide variety of tapa and little is known about the long-term effects of any of the treatments. Different approaches have been taken depending mainly on the conservator's background. Some have treated tapa as a textile, others as paper and, in a few cases, tapa has been treated as a woody material with polyethylene glycol (PEG) and polyvinyl acetate-based adhesives.

Several different processes are mentioned in the tapa conservation literature: repair or support (by patching, pulp-filling or complete lining) and deacidification. Because of the fragility and low pH of this particular tapa, there was little point in just lining the cloth without first considering a method of neutralising the acidity, so both aspects were considered.

Many methods of deacidification have been reported in the literature (especially for paper) and these can be divided into two broad categories, aqueous and non-aqueous; non-aqueous methods form the smaller category. Magnesium methyl carbonate (in methanol) has been sprayed onto very fragile tapa. The results have not been evaluated although the technique is reported to have raised the surface pH (Barton and Weik 1994). It has been used successfully in paper conservation but the results depend upon the initial acidity of the paper (Green and Leese 1991). The disadvantage of using a non-aqueous method on a barkcloth of this size is the large volume of methanol that would be required. On the grounds of health and safety (largely due to a lack of large-scale air extraction facilities), aqueous methods were examined first. Subsequent testing of all the tapa dyes confirmed that they were all stable in water.

Most conservators agree about the use of deionised water for aqueous washing, providing that the dyes or pigments are not fugitive. Wash times in the literature vary from several short rinses to a full hour's immersion in warm water. Non-ionic detergents (e.g. Synperonic and Lissapol) and carboxymethyl cellulose (CMC) are sometimes added to the wash water, particularly when the tapa is dirty. Many different reagents have been added to acidic paper (Lienordy and van Damme 1990), but only a few have been used for tapa; sodium citrate, magnesium bicarbonate and calcium hydroxide. A solution of sodium citrate was used in a 6 per cent solution of PEG 400 (Bakken and Aarmo 1981) on an unsourced piece of tapa to buffer and give flexibility. The PEG 400 made the tapa more flexible and successfully bonded delaminating layers together. The Bishop Museum (Rose *et al.* 1988; Green 1997) also experimented with PEG 1500 to restore flexibility. They concluded that washing might be more promising because it can restore the hydrogen bonding between the fibres and that more research was needed. The Fiji Museum has successfully treated Samoan tapa with magnesium bicarbonate solution and a Hawaiian tapa was treated with calcium hydroxide. The Bishop Museum conservators have looked at specific problems of tapa conservation, in particular oiled Hawaiian tapa and *mamāki*. There is a brief mention of Samoan tapa, noting that it is particularly at risk from acidity caused by the dyes, but no treatment is suggested.

Tapa repair has mainly taken the form of the addition of small patches of lining or full lining, depending on the condition. Backing and repair materials generally tend to be Japanese papers of various weights, paper pulp (Green

1997) or new tapa. Opinion is often divided about the use of Japanese papers for patching, but this seems to be mainly influenced by the nature of the tapa being repaired. The complete lining of a tapa cloth is usually considered to be the last resort, but given the nature of the damage in this case, the use of multiple small patches or leaf casting (Green 1997) would be untidy and time consuming. Inevitably the tapa will lose some of its flexibility with a full support, but as this cloth is not strong enough to be rolled or handled extensively, this was not considered to be a major problem.

As new tapa is not easy to obtain, a medium weight Japanese mulberry paper (*Usomino*) (Rose *et al.* 1988) was chosen for backing the tapa but Rose *et al.* also mention the use of other Japanese papers such as *Sekishu*, *Tengujo* and *Kizukishi*. The option of stitching the tapa to a support was eliminated due to the structure of the tapa fibre; stitch holes tend to spread on non-woven materials. The choice of adhesives was the next important decision. In the past, a wide range of adhesives has been used: starches (wheat, rice, tapioca (Häkäri 1995) and arrowroot), cellulose ethers (methyl cellulose (MC) (Green and Fullman 1980)), carboxymethyl cellulose (CMC) (Bakken and Aarmo 1981) hydroxypropylcellulose (HPC, Klucel G) (McCord 1996) polyamide resins (Munro 1981) and polyvinyl acetate-based (PVAC) adhesives (Norton 1984). The long-term properties of polyamide resins are suspect particularly as they are very different materials to tapa and paper; PVAC-based adhesives tend to yellow and become acidic with time. Both MC and the starch adhesives are popular with conservators. Some use both and report little difference in their properties (Green and Fullman 1980). Of the cellulose ethers, MC has the best long-term stability (Horie 1987; Feller and Wilt 1990), is resistant to micro-organisms and does not react with metal ions. It is important when using starch adhesives to get the viscosity right to achieve the best compromise between adhesion and flexibility. This is also true of MC, but the viscosity is not only controlled by the concentration, but by other factors such as the degree of substitution (DS) and the degree of polymerisation (DP) (University of Northumbria n.d.), which are rarely mentioned in the literature. An increase in DS or DP increases the viscosity of MC, increases the adhesive strength and reduces the penetration of MC into the material. High substitution MC will make the tapa less flexible and has a tendency to leave a shiny surface because it remains on the surface. Both MC and the starches are adversely affected by acids but the addition of a buffer to the tapa will hopefully reduce this problem. Starch adhesives also slowly revert (Daniels 1995) and, in time, become insoluble in cold water. As there were a similar number of pros and cons to each type of adhesive, MC was selected on grounds of familiarity and ease of preparation. A medium substitution MC was originally selected, but as the suppliers were out of stock, a high substitution MC was used instead (Culminal

MC2000, a high substitution non-ionic cellulose). Although this will affect the tapa's flexibility, the MC is not deeply absorbed into the tapa fibres. Using *Usomino* paper and MC there will be no confusion between the old and the new – this was a common problem reported in the literature as many modern repairs have been carried out using traditional materials e.g. tapa and starch adhesive.

Aqueous treatment proposal

Before proposing an aqueous treatment, the tapa dyes and pigments were all tested for their mobility in water and found to be colourfast. Each was tested with a wet paint brush, the 'tadpole' test, and some tiny fragments were soaked for 30 minutes in water and dried on blotting paper; no colour movement was observed. The cloth was closely examined again to confirm that there were no joins or laminations that might come apart during treatment. Also, the tapa appeared not to have been smoked (smoked tapa tends to disintegrate in water), oiled or previously repaired. Dirt analysis would not have provided much useful information because of heavy contamination from the Manchester atmosphere, so its removal was not considered to be a great loss.

The decision to use a small amount CMC and Synperonic N in the initial wash solution was made on the grounds of the amount of dirt and dust embedded in the cloth; CMC to help hold dirt in suspension and Synperonic to aid wetting. $Ca(OH)_2$ and $Mg(HCO_3)_2$ were selected for testing as alkaline buffers, as these both leave an alkaline residue in the cloth. Four, tiny, loose fragments taken from the bag, two red-brown and two black (glossy) were immersed in solutions of the two buffers for 30 minutes. The $Ca(OH)_2$ solution had a pH of 10 and the $Mg(HCO_3)_2$ solution a pH of 8. A slight yellow discolouration was noted in the $Ca(OH)_2$ in the sample tube containing the black glossy sample and afterwards, a slight white residue was also noticeable on this sample and the gloss had a much shinier appearance. Because of these observations and because it is a less aggressive alkali, $Mg(HCO_3)_2$ was selected as the buffering agent.

A preliminary trial was loosely based on a method used by Zobl (as described in Barton and Weik 1994) in which $Ca(OH)_2$ was replaced by $Mg(HCO_3)_2$. This is a cautious method in terms of immersion time (15–20 mins in total). The following method was used on another small red-brown sample from the tapa, in a glass Petri dish with a solution, 2cm in depth:

- five-minute immersion in deionised water containing 0.05% CMC and 0.004% Synperonic-N
- two 5-minute rinses in deionised water

- immersion in a solution of $Mg(HCO_3)_2$ for 30 minutes (approx. 0.05M, the concentration generally used in paper conservation)
- dried on blotting paper.

In practice, this procedure resulted in a considerable colour change. The red-brown colour looked considerably darker and had lost most of its redness.

Measuring the effect of pH on the red-brown dye colour

There is no mention of colour change in the tapa literature, but it is known that some natural organic dyes can be altered by a change in pH. Turmeric is known to change from yellow to red/brown in alkaline conditions (Lee *et al.* 1985). To confirm whether the colour change of the red-brown dye was related to pH or just to the use of $Mg(HCO_3)_2$, a fresh sample was washed, buffered (as before) and then immersed in a series of pH buffers (citric acid/Na_2HPO_4 solutions) (Hudson and Hayes n.d.) ranging from pH 3 to 8 for about six minutes with gentle agitation. The solutions were monitored throughout with a glass electrode pH meter (Pye Unicam Model 292 Mk 2 pH meter) calibrated daily with standard commercial buffer solutions. After the sample had been allowed to dry overnight, objective colour measurements were taken at each stage with an ER10 Fast Mobile Spectrocolorimeter. Three separate colour measurements were taken at each stage, removing and replacing the sample on the mount (Fig. 6.2) between each individual measurement. The three readings were then averaged to reduce error caused by measuring the colour in slightly different locations.

Results of pH colour measurements

The spectrocolorimeter software (Johne & Reilhofer Electroptics, Munich), expresses results using the CIELAB system (Commission Inter nationale de L'eclairage $L*a*b*$ system) which is represented by 3-D colour solid (Anon. 1994) in Figure 6.3. The location of the measured colour on the space is determined by three co-ordinates measured by the spectrocolorimeter; the $L*$, $a*$ and $b*$ values or alternatively the $L*$, $h*$ and $C*$ values. The two sets of values are just different co-ordinate systems shown in Figures 6.3 and 6.4. The $L*a*b*$ co-ordinates are Cartesian (i.e. x, y, z co-ordinates) and the $L*C*h*$ co-ordinates are cylindrical (i.e. r, θ, z co-ordinates). The results can also be expressed as a single number ΔE (*delta E*) to indicate the extent of the overall colour change.

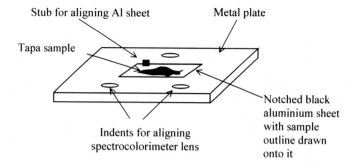

Figure 6.2 Diagram of plate for aligning spectrocolorimeter lens

Figure 6.3 Cartesian system $L*a*b*$

ΔE is calculated from the change in the $L*$, $a*$ and $b*$ values (represented by $\Delta L*$, $\Delta a*$ and $\Delta b*$) using the following equation:

$$\Delta E = \sqrt{\left(\Delta L *\right)^2 + \left(\Delta a *\right)^2 + \left(\Delta b *\right)^2}$$

A ΔE value of one is accepted to be the minimum colour change that is detectable by the human eye. The $L*C*b*$ system is useful for determining the 'type' of colour change by plotting $\Delta L*$ against $\Delta C*$ (Fig. 6.5).

For clarity, the results presented on the 2-dimensional Figures 6.6, 6.7 and 6.8, and Tables 6.1 and 6.2, which clearly show that there is relationship between the pH and the dye colour. If the colour change was just due to dye loss, or removal of dirt, the $L*$ values would be expected to increase throughout, corresponding to a lightening in colour. Instead $L*$ values vary with pH,

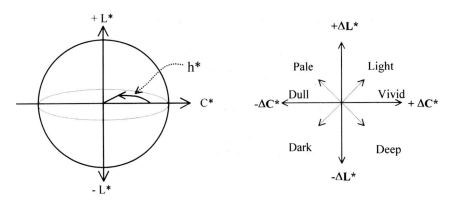

Figure 6.4 Cylindrical system $L*C*h*$
(C = chroma, h = hue)

Figure 6.5 Terms used to describe differences in chroma and lightness

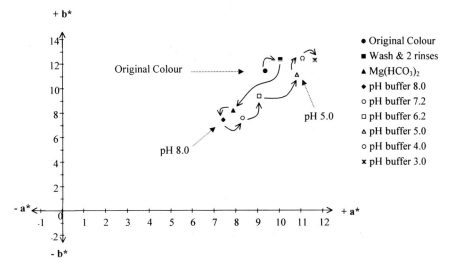

Figure 6.6 Changes in $a*$ and $b*$ values of the red-brown dye with pH

becoming darkest when the pH reaches 8. By comparing Figure 6.5 with Figure 6.8, the red-brown colour definitely becomes darker with increasing pH. The $a*$ and $b*$ values also decrease at higher pH, losing some of the red and yellow components of the colour. As the pH is lowered again with the buffer solutions, the colour is restored to red-brown. The ΔE value also confirms that the greatest overall colour change occurs at the highest measured pH (8.0) with a very visible 8.2 units. The final measurements do not exactly match the initial ones; this may be due to changes in the dirt content and organic components of the tapa cloth itself. Changes in the colour of plain tapa have already been

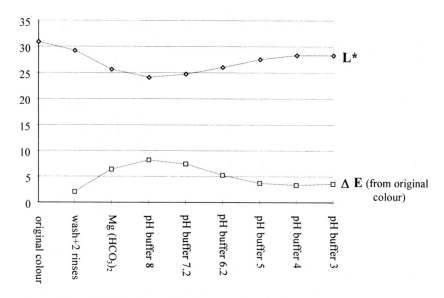

Figure 6.7 The change in L* values and ΔE of the red-brown dye with pH

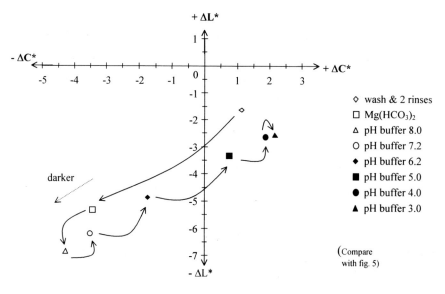

Figure 6.8 The effect of pH on the red-brown L* and C* values

noted with a change in pH due to the behaviour of the tannin content (Daniels 1996). There might have been a change in the tapa colour, but this would have been disguised by the more dramatic colour change of the red-brown dye.

Table 6.1 Measured colour changes as a result of pH change

Solution	L^*	a^*	b^*	b^*	C^*	Observations
Original colour	30.94	9.36	11.45	50.74	14.79	Red-brown colour. Reverse side has thin tapa stripes of uncoloured tapa
After wash and two rinses	29.3	10.05	12.36	50.84	15.93	Little colour change visible (pH of final rinse at 5.5)
$Mg(HCO_3)_2$	25.62	7.87	8.18	46.07	11.35	Colour has become darker and less red (pH 6.6)*
pH buffer 8	24.08	7.43	7.45	45.11	10.52	
pH buffer 7.2	24.74	8.32	7.60	42.41	11.27	
pH buffer 6.15	26.07	9.07	9.37	45.94	13.05	Tapa colour is beginning to look paler. Red colour returning
pH buffer 5	27.60	10.84	11.13	45.73	15.54	
pH buffer 4	28.31	11.07	12.45	48.37	16.66	Pigment looks noticeably redder
pH buffer 3	28.37	11.66	12.32	46.59	16.96	Definite red colouration. Thin stripes of plain tapa still visible

*Fresh $Mg(HCO_3)_2$ often has a slight acidic pH due to the amount of CO_2 dissolved in the solution. pH usually increases with time.

Table 6.2 Measured colour changes before and after deacidification and buffering treatment

Colour	L^*	a^*	b^*	C^*	H^*	ΔE
Brown-red						
before	35.55	9.36	12.12	15.31	52.32	–
after	27.39	7.18	8.08	10.81	48.37	–
change (Δ)	–8.16	–2.18	–4.04	–4.50	3.95	9.36
Plain tapa						
before	60.46	4.23	16.98	17.50	76.01	–
after	57.77	3.84	13.65	14.18	74.27	–
change (Δ)	–2.69	–0.39	–3.33	–3.32	1.74	4.30
Dark brown						
before	27.09	1.36	2.91	3.22	64.93	–
after	20.16	1.55	1.61	2.23	46.13	–
change (Δ)	–6.93	0.19	–1.30	–0.99	18.80	7.05
Black						
before	25.64	0.53	0.50	0.72	43.25	–
after	16.43	0.81	0.68	1.06	320.25	–
change (Δ)	–9.21	0.28	0.18	0.34	83.00	9.22

To deacidify or not?

The ethical question

Treatment involving complete immersion in water and alkaline solutions is not without risk. Water is usually very much involved in the production of tapa, and its effect is quite well known. However, alkaline solutions can remove hemicelluloses causing a loss in flexibility and this is often quoted as the reason for not deacidifying unless absolutely necessary. Hemicelluloses are also believed to help protect lignin from photo-degradation, thus alkalis can indirectly increase the rate of tapa deterioration (Barton and Weik 1994). On the other hand, alkali earth ions are known to stabilise cellulose. Although the mechanism is not fully understood, it is thought that they inhibit both oxidative and hydrolytic degradation thus possibly counterbalancing any increase brought about by the loss of hemicellulose. Deacidification would also involve an inevitable colour change, which has already been demonstrated by the colour measurements. The change could perhaps be considered as a reversion to the original colour, when the new tapa had a pH of around 6. However, as the literature mentions the use of acidic dyes, there is also the possibility that the dye is still close to its original colour and that the tapa has merely absorbed its acidity. Only an increased knowledge about the dyes and their behaviour will resolve this issue.

There was also the risk that other dyes may also change colour with change in pH. Although it is unlikely to be particularly noticeable in the black pigments, there may be a noticeable change in the natural tapa colour. Testing samples of plain tapa or the dark brown dye was not possible without deliberately removing them from the cloth. The low pH will ensure that the acid degradation will become progressively faster causing the cloth to collapse into many small pieces unless some form of interventive action is taken. The attachment of a backing would hold the pieces together for a while but the low pH would ensure that the fibres would continue to degrade at increasing speed. The acidic tapa would also be an aggressive environment for an adhesive.

Given these problems, it was debatable whether deacidification and buffering could be ethically or aesthetically acceptable. After discussion and consultation with the Manchester conservation team, Nicola Walker, paper conservator at the Whitworth Art Gallery and Dr Bankes, the Keeper of Ethnology, it was agreed that the tapa should be deacidified and buffered as an experimental procedure. Given the state of the tapa, there was no doubt that its survival would be dependent upon an interventive treatment that would neutralise the acidity or, at the very least, raise the pH to a safer level (pH>4). The trial procedure used would be adapted or adjusted as needed during the treatment, depending upon the behaviour of the tapa.

Deacidification and buffering on a large scale

The first hurdle in treating a barkcloth of this size was finding a large enough bath. A number of places were approached in the Manchester area but without success; treatment sites further afield were not considered because of the barkcloth's fragility. An old wooden packing crate was eventually located and double lined with Polythene sheeting with the aid of double-sided tape and a staple gun in true 'Blue Peter' style. A waterproof vacuum cleaner was used as a means of emptying the bath during treatment. A support cloth for the tapa was put together from two sheets of non-woven polyester, kindly loaned by the Whitworth Art Gallery, joined with waterproof tape to give a flat join (the tape was tested beforehand in alkaline solutions). The reagents were prepared, based on the 50l capacity of the bath (see Appendix 1 for preparation of magnesium bicarbonate solution), after preparing the appropriate Control of Substances Hazardous to Health (COSHH) risk assessment forms.

Because of the colour change noted earlier, all of the dye colours and the plain tapa were measured to monitor all the pigment colours and the non-decorated tapa itself before and after treatment. The points (10mm diameter) for colour measurement were selected from areas of fairly even colour. Sections of the barkcloth design around these points were then traced onto a sheet of Melinex that was also marked with the position of the spectrocolorimeter alignment ring (Figs 6.9 and 6.10). Three readings were also taken each time and averaged as before. The dimensions of the complete cloth were also recorded by tracing the outline onto a large sheet of lightweight Melinex before treatment. A thorough photographic record was also made by Geoff Thompson, the museum photographer.

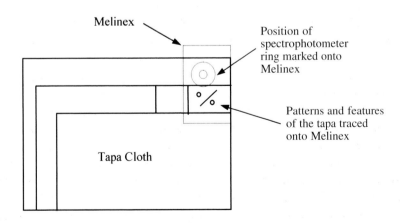

Figure 6.9 Diagram showing method of repositioning the spectrocolorimeter (see Figure 6.10)

Figure 6.10 Measuring the tapa colours with the spectrocolorimeter before deacidification

The tapa was humidified overnight to RH ca. 70% to reduce the shock of complete immersion from the dry atmosphere of the conservation laboratory (RH 30–40%). The magnesium bicarbonate solution was titrated (see Appendix 1) and found to have a concentration of about $0.1 \, \text{mol} \, \text{dm}^{-3}$, about twice the concentration needed. The pH of every treatment solution was monitored throughout with a calibrated glass electrode pH meter.

Treatment procedure

The makeshift bath was filled to a depth of about 2cm with deionised water, 10cm^3 of Synperonic-N and 500cm^3 of a 0.5 per cent solution of CMC. The tapa was gently lifted into the bath on its non-woven support and gently pushed under the water from one end to the other, as the cloth started to wet unevenly. The cloth was patted from the centre to expel air bubbles trapped below. This process took about 15 minutes, by which time a lot of yellow brown discolouration was visibly leaching from around the edges. The pH of the wash solution dropped to a low 3.5 (from 5.8) demonstrating just how much acid there was in the cloth. The vacuum cleaner was found to be a very efficient foam generator and this was used to monitor how much of the surfactant was left in the series of rinse solutions. Each rinse took about ten minutes in practice including the amount of time it took to fill the bath, gently agitate the cloth and then empty the bath. A joint decision was made to continue rinsing until the pH settled, which occurred after six rinses when the pH reached a

stable 4.7. The magnesium bicarbonate solution was then roughly diluted 50/50 with deionised water and added to the bath after determining its concentration by titration (0.06 mol dm^{-3} – see Appendix 1). The cloth was left for 30 minutes to ensure that a good amount of the buffer was absorbed into the cloth. Some yellow discoloration of the water reappeared, probably due to the mobilisation of more organic materials in the tapa. After this time the tapa looked considerably darker. This was felt to be unacceptable, so an additional amount of deionised water was added to the treatment bath which lightened the colour. The bath was then tilted to drain excess rinse water and the cloth was lifted onto a blotting paper-covered wire mesh. After further blotting to remove excess water the tapa was left to dry slowly. When just damp, the cloth was sandwiched between two large sheets of acid-free corrugated card and turned over. The wash support was rolled off and the edges were weighted with small bags of lead shot to prevent the cloth shrinking too much (similar to the technique often used by many tapa makers). When dry the colour measurements were repeated using the Melinex alignment sheets and the tapa was reassessed.

Assessment after deacidification and buffering

In terms of raising the pH, the method was a success: a pH of ca. 6 was achieved, similar to that of fresh tapa. The spectrocolorimeter measurements show that colour changes occurred in all the colours (Figs 6.11 and 6.12). Every colour measured became darker (L^* values all decreased), which was not entirely unexpected. The greatest change occurred in the red-brown dye, with a visible change of 9.4 units in the ΔE value. The black dye also showed a surprisingly large colour change of 9.2 units, which wasn't obvious to the naked eye. The smallest change (ΔE of 4.3) was observed on the undecorated tapa. A component of the dye colour changes may be attributed to this change, but as the dyes all have a greater ΔE value, there is also an inherent change within the dyes themselves. The flexibility and strength of the cloth did not appear to be much improved.

Lining procedure

After deacidification the tapa was still in need of additional support, therefore it was decided that a complete backing sheet should be applied. Several sheets

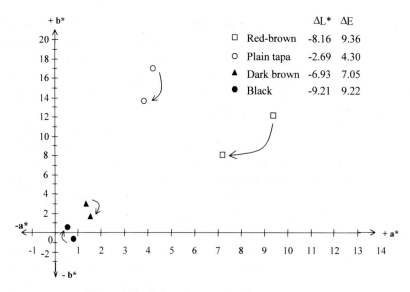

Figure 6.11 Colour changes caused by tapa deacidification

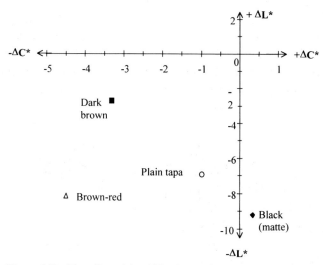

Figure 6.12 The effect of deacidification on the *L** and *C** values (compare with Fig. 6.5)

of *Usomino* paper were toned to a more sympathetic colour by liberally brushing them, using a large soft brush, with a dilute suspension of Winsor & Newton acrylic paint (raw umber) in deionised water. The paper was sprayed with water beforehand to help ensure that an even colour was achieved. When dry, the edges of the paper were wet torn to give a softer edge; they were also

wet torn into smaller pieces for easier handling. The pieces were then arranged over the back of the tapa to make sure that no paper joins coincided with areas of extended weakness or holes. An overlap of about 4cm over the edges of the tapa was also included. A solution of 3% methyl cellulose was made up by adding the MC to a beaker of deionised water on a magnetic stirrer. After standing overnight, any remaining lumps of MC had dissolved.

The entire cloth was humidified overnight and then sprayed with a fine mist of deionised water just before lining. The *Usomino* sheets were pasted with MC, diluted slightly to a thinner paste, using a large Japanese brush. By lifting each sheet with a long ruler, the *Usomino* paper was laid onto the tapa and 'tamped' down with a large Japanese brush, leaving an overlap over the tapa edges (Fig. 6.13). The *Usomino* was then covered with blotting paper and brushed more firmly to ensure good contact between the lining and the tapa and to remove excess water. The cloth was repeatedly sprayed with water during the entire procedure to keep it evenly damp and to prevent rucking caused by uneven drying rates. The cloth was left to dry with the lead weights around the edges. When dry, additional *Usomino* tabs of double thickness were attached to the paper overhang in six places around the cloth so that the cloth could be pinned to a support without pinning through the cloth itself.

An overlap of paper was left around the edge for support and this may be removed at any time. The cloth was pinned to a large sheet of acid-free corrugated card with stainless steel tacks pushed through the tabs. As the keeper was very keen to have the cloth easily visible without handling, the entire board was wrapped with lightweight Melinex in such a way to allow easy access with minimal disturbance (Fig. 6.14).

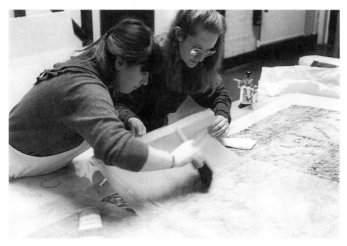

Figure 6.13 Lining the barkcloth with *Usomino* paper

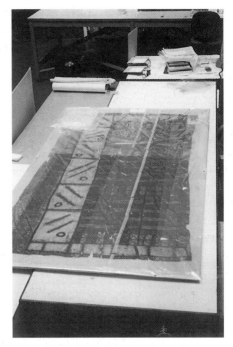

Figure 6.14 Barkcloth ready for storage after treatment

The usual recommendations were made for the storage of the tapa, namely a stable RH ca. 55%, and a cool stable temperature (Anon. n.d.). It was also recommended that this tapa should not be put on display because of its condition and that handling should also be kept to a minimum. The dark stable environment of the ethnology store would provide more appropriate conditions.

Conclusions

The conservation treatment of this tapa was a success in that the pH of the acidic tapa was raised but additionally the new paper lining and storage method mean that the cloth can be handled safely and is easily viewed. Also the reverse side of the tapa can be seen through the paper backing. The cloth is much stronger and can be handled without the loss of small fragments. Although it is not flexible enough to be safely stored on a roll like the majority of the collection, the flat storage means that it is much easier to examine on regular basis. By comparison with the barkcloth outline drawn before conservation, the dimension change in the cloth was quite small. The cloth is very slightly

longer and slightly wider, up to 2cm at one end (a change of about 1.9 per cent), mainly due to the fact that one of the central cracks drifted apart during lining.

The tapa has lost some of its flexibility. This might be have been improved by using a lower substitution MC adhesive, but on the other hand a lower substitution MC may have been more difficult to reverse because of deeper absorption into the tapa fibres. Further testing of different consistencies and substitutions is required to find the best compromise. The addition of PEG 400 may also have been a possibility, although as yet, the long-term effects on tapa have not been evaluated.

It is not possible to comment, without further analysis of the cloth, on how much buffer is present in the tapa to protect against future acidity or to calculate how long it will remain effective – only time will tell. Aqueous treatments such as that used in this project are no longer considered routine, but as yet there is no ideal replacement for treating such high levels of acidity. In the light of research into the effect that alkalis have on paper (which has a fairly similar composition to tapa), aqueous buffering should be used only as a last resort for tapa. Just how much the addition of alkali metal ions can counteract the loss of hemicelluloses is not yet clear, and more research is needed. Even if an ideal aqueous method of treating acidity were to be found, there is still the problem that most barkcloths are coloured with dyes that are fugitive in water or have been joined, laminated or repaired with water-soluble adhesives. Treating large sheets of tapa with solvent-based solutions is possible, provided that good, large-scale air extraction or filtering facilities are available.

There is no doubt that the colour of the dyes must also be considered when adding alkali to acidic tapa. Aesthetically, the colour change did not make a major difference to the appearance of the cloth and was generally felt to be acceptable, although this was at the expense of losing some of the alkaline buffer in the cloth. It is possible that the colours are now a little closer to their original hues before the tapa became acidic, but on the other hand the tapa may have absorbed acidity from the dyes. More information about the dyes is the only way to resolve this issue. Therefore, ideally the next step would be to analyse and identify all the dyes. It may be possible to investigate neutral 'buffers', such as magnesium sulphate, that have been used in textile conservation and may be an option for use on brittle tapa with pH-sensitive dyes. The drawback is that $MgSO_4$ is not a pH buffer in the true sense although it is often erroneously treated as one in the literature. Although $MgSO_4$ adds Mg^{+2} ions, which are believed to assist in stabilising cellulosic materials, the sulphate ion plays no role in counteracting acidity, unlike true pH buffers which leave carbonate or hydroxide ions in the fibres. In fact, if the cloth acidity does increase again, the sulphate could become a potential problem. A long-term aim may be the creation of a colour database with information about how each

particular dye responds to water, solvents and alkalis. Analysis of dyes in conjunction with fibre analysis of the tapas would also provide a very useful tool in the identification of the origins of unprovenanced barkcloths.

Finally, more research is required before a reasoned conservation method can be found. The problem of extreme acidity in barkcloths such as this one needs to be addressed; attaching such cloth to a backing is a short-term solution in these conditions of low pH. However, if this approach is adopted, perhaps buffered adhesives should be considered because the acidic environment will affect the stability of many adhesives. A buffered adhesive may also help to counteract the acidity of the tapa, although its effect may be largely superficial unless the adhesive is thoroughly absorbed by the tapa.

There is no ideal solution for acidic barkcloths and the chemistry involved in barkcloth degradation is still not fully understood. Should the conservation treatment cause problems in the future, there is a least a thorough photographic record of the cloth before and after the treatment. More systematic research needs to be carried out, taking into account the wide variety of barkcloths and dyes that exist. At the very least, this information may help to identify barkcloths that are particularly at risk from rapid deterioration.

Acknowledgements

I would like to thank Nicola Walker from the Whitworth Art Gallery for her assistance and practical advice, especially in lining the tapa; Agnes Homoky for assisting with the dry cleaning of the tapa; Roy Garner for taking photographs during the deacidification and for maintaining the deionised water supply; Velson Horie for encouraging me to go ahead and for advice; Geoff Thompson, the museum photographer, for making a thorough photographic record of the tapa before and after; Michaela Augustin-Jeutter for lending a hand and Dr George Bankes the Keeper of Ethnology for granting permission to treat the tapa in this way.

References

Anon. (n.d.) *The Care of Tapa*. Pacific Regional Conservation Center. Hawaii: The State Museum of Natural and Cultural History.

Anon. (1994) *Precise Color Communication*. Minolta.

Bakken, A. and Aarmo, K. (1981) 'A report on the treatment of barkcloth', *ICOM 6th Triennial Meeting*, Ottawa.

Barton, G. and Weik, S. (1994) 'The conservation of tapa', *The Conservator* **18**, 28–40.

Daniels, V. (1995) 'Starch adhesives', in *Starch and other Carbohydrate Adhesives for Use in Textile Conservation*. London: UKIC Textile Section.

Daniels, V. (1996) Personal communication (via C. V. Horie).

Feller, R. I. and Wilt, M. (1990) Evaluation of cellulose ethers for conservation. *Research in Conservation*. Vol. 3. Los Angeles: The Getty Institute.

Gathercole, P. (1996) Personal communication.

Green, L. R. and Leese, M. (1991) 'Non-aqueous deacidification of paper with methyl magnesium carbonate', *Restaurator* **12**, 147–62.

Green, S. W. (1997) 'Conservation of tapa cloth and filling voids', *The Paper Conservator* **11**, 58–62.

Green, S. W. and Fullman, G. (1980) 'Notes on the treatment of Fijian tapa cloths', *ICCM Bulletin* **6**(3–4), 58–64.

Häkäri, V. (1995) 'The conservation of tapa using tapioca paste', in *Starch and Other Adhesives for Use in Textile Conservation*, P. Cruickshank and Z. Tinker (eds). London: UKIC, Textile Section, 14–19.

Horie, C. V. (1987) *Materials for Conservation*. London: Butterworth Heinemann.

Hudson, P. F. and Hayes, O.B. (n.d.) *1st Technicians Handbook*. London: Solus Publishing.

Lee, D. J., Bacon, L. and Daniels, V. 1985. 'Some conservation problems encountered with turmeric on ethnographic objects', *Studies in Conservation* **30**, 184.

Lienordy, A. and van Damme, P. (1990) 'Practical deacidification', *The Restaurator* **11**, 1–21.

McCord, M. E. A. (1996) 'The treatment of large flat fabrics in the British Museum', *ICCM Bulletin* **12**(1–2), 71–6.

Munro, S. N. (1981) 'The conservation of a Hawaiian sleeping tapa', *ICOM 6th Triennial Meeting*, Ottawa.

Norton, R. (1984) 'Stabilisation, mounting and packing of a Tahitian mourner's costume', *ICCM Bulletin* **10**, 35–53.

Rose, R., Turchan, C., Firnhaber, N. and Brown, L. O. (1988) The Bishop Museum Tapa Collection Conservation and Research in Special Problems. *Bishop Museum Occasional Papers*, 28. Honolulu: Bishop Museum Press

University of Northumbria (n.d.) *Aqueous adhesives, methyl cellulose (MC) and sodium carboxymethyl-cellulose*. Student Information Sheet, Department of Conservation, University of Northumbria, Newcastle.

Appendix 1: Preparation of reagents and titration procedures

Preparation of magnesium bicarbonate solution

Due to the large amount of magnesium required (25 litres), and on the grounds of safety (after a soda siphon exploded) the 'soda siphon method' was abandoned. Instead, a larger scale method adapted from Burgess and Boronyak-Szaplonczay (1992) was used. The solution was prepared from a laboratory surplus of basic magnesium carbonate light (basic magnesium carbonate light is not a stoichiometric compound, BDH Merck provided an approximate formula $4MgCO_3.Mg(OH)_2.2H_2O$ with an average molecular weight of 486g)

that has an approximate formula $4MgCO_3.Mg(OH)_2.2H_2O$. The quantities were calculated assuming the following equation:

$$4MgCO_3.Mg(OH)_2.2H_2O(s) + 6CO_2(aq) + 2H_2O(l) \rightarrow 5Mg(HCO_3)_2(aq)$$

This method is essentially based on the same chemical reaction, but the maximum achievable concentration is only is 0.2 mol dm^{-3}, assuming standard conditions (25°C, 1 atm) and that the solution is saturated with CO_2 gas (Gmelin 1924–1990). The main difference is just the pressure at which the reaction is done.

Procedure

About 500g basic magnesium carbonate (this is in excess of the quantity needed) was added to a clean 25l aspirator filled with deionised water (Elgstat C114). The suspension was continuously agitated with a motorised stirrer. CO_2 was introduced at a steady rate through a gas bubbler supplied from a CO_2 gas cylinder for about 48 hours. The concentration of the solution was monitored by titration against ethylene diamine tetra-acetic acid (EDTA) (see below).

EDTA titration procedure for determining the concentration of $Mg(HCO_3)_2$ solution

The concentration of the bicarbonate solution was monitored by titrating a $25cm^3$ sample against 0.1 mol dm^{-3} EDTA with Solochrome Black indicator using a method adapted from Vogel (1979). The colour of Solochrome Black indicator depends upon the pH of the surrounding solution (Table 6.3).

Table 6.3 Colour vs pH of Solochrome Black indicator

Solution pH	Colour	Indicator ion present
<pH 5.5	Red	H_2D^-
pH 7–11	Blue	HD^{-2}
pH>11.5	Yellow/orange	D^{-3}

D represents the ion

92

For this titration, the pH range of 7–11 is the useful one, because if certain ions are present in the solution, the indicator colour is red instead of blue. Mg^{+2} is one of the ions that forms a red complex with the indicator which can be represented as an equation:

$$Mg^{+2} + HD^{-2} \rightarrow MgD^- + H^+$$

$$\text{(blue)} \qquad\qquad \text{(red)}$$

When EDTA is added to the solution, it sequesters the Mg^{+2} ions from the magnesium-indicator complex forming a stable colourless MgEDTA complex, thus restoring the blue colour of the indicator (HD^{2-}).

$$MgD^- + EDTA^{2-} + H^+ \rightarrow HD^{-2} + MgEDTA$$

$$\text{(red)} \qquad\qquad\qquad \text{(blue)} \quad \text{(colourless)}$$

Therefore, provided that the solution pH is kept between 7 and 11 with a pH buffer (e.g. ammonium hydroxide/concentrated ammonia), the amount of EDTA needed to restore the solution to a pure blue colour indicates the amount of Mg^{2+} ions present.

Preparation of titration reagents

- **Indicator solution:** dissolve 4.0g of Solochrome Black indicator in 100ml of methanol. This solution is stable for about 1 month.
- **Buffer solution:** dissolve 17.5g of ammonium chloride in $142cm^3$ of concentrated ammonia. Make up to $250cm^3$ with deionised water.
- **EDTA solution (0.1 mol dm^{-3}):** dissolve 37.2g of disodium EDTA in 1l deionised water (a great accuracy was not needed, the solution was not standardised).

Titration procedure

$25cm^3$ of magnesium solution was pipetted into a conical flask with $2cm^2$ of the clear magnesium bicarbonate solution. A burette was filled with 0.1 mol dm^{-3} EDTA. A pH electrode was placed into the solution and a few drops of concentrated ammonia were added to bring the pH to 10 if needed. (USE CAUTION when using concentrated ammonia). A few drops of the indicator solution were then added and the solution was titrated against the

EDTA solution. A colour change from red to pure blue indicates the endpoint. (A white tile under the conical flask makes the colour change more obvious.) The molarity of the magnesium bicarbonate solution was calculated assuming: 1 mole EDTA \equiv 1 mole Mg^{+2} \equiv 1 mole $Mg(HCO_3)_2$

Preparation of buffer solutions

Citrate/phosphate buffer solutions were prepared for a range of pH values 3–8 by mixing the following solutions in the proportions listed in Table 6.4.

- **0.1 mol dm^{-3} citric acid:** dissolve 21.01g of citric acid into 1l of boiled deionised water.
- **0.2 mol dm^{-3} Na$_2$HPO$_4$:** dissolve 28.40g of $Na_2 HPO_4$ in 1l of boiled deionised water.

Table 6.4 pH and volumes of buffer solutions

pH of buffer solution (100ml at 25°C, 1atm)	Volume of 0.1 mol dm^{-3} citric acid	Volume of 0.2 mol dm^{-3} Na$_2$HPO$_4$
3.0	79.5	20.5
4.0	63.0	37.0
5.0	50.7	49.3
6.0	37.9	62.1
7.0	17.7	82.3
8.0	4.2	95.8

Buffer solution pH was measured with a pH meter calibrated with commercial buffer solutions before use.

Health and safety

Normal laboratory procedures were followed to comply with all health and safety requirements. Use special care when handling concentrated ammonia and methanol.

References

Burgess, H. D. and Boronyak-Szaplonczay, A. (1992) 'Uptake of calcium or magnesium into seven papers during aqueous immersion in calcium or magnesium solutions', *The Institute of Paper Conservation Conference Papers*, Manchester.

Gmelin, L. (1924–1990) *Gmelin Handbuch der Anorganischen Chemie*. Gmelin Institute. Berlin: Springer Verlag.

Vogel, A. I. (1979). *Textbook of Quantitative Inorganic Analysis*. Longman: New York and London, Ch. X.

Materials and suppliers

All chemicals, pH buffer solutions, indicator papers and Solochrome Black indicator:

BDH, Merck Ltd
Merck House
Poole BH15 1TD

'Chemical sponge':

A & J Beveridge Ltd
Derwenthaugh Industrial Estate
Swalwell
Newcastle Upon Tyne NE16 3BJ

CO_2 gas:

BOC Industrial Gases
PO Box 12
Priestley Road
Worsley
Manchester M28 2UT

Usomino paper:

Conservation by Design Ltd
Timecare Works
60 Park Road West
Bedford MK41 7SLP

Methyl cellulose (Culminal MC2000) and Carboxymethyl cellulose (7H):

Hercules Ltd
Langley Road
Salford M6 6JU

Acid-free cardboard tubing and Salton Ultrasonic Humidifier:

Preservation Equipment Ltd
Shelfanger
Diss
Norfolk IP22 2DG

Acrylic colour:

Winsor & Newton
Whitefriars Avenue
Wealdstone
Harrow
Middlesex HA3 5RH

Research, exhibition and preservation of the barkcloth collections from the Pacific in the Harvard Peabody Museum

T. Rose Holdcraft

Introduction

The extensive anthropological object holdings and associated paper and photographic documentation housed at the Peabody Museum of Archaeology and Ethnology at Harvard University serve a national and international community for scholarly research, teaching, publication, exhibition and public education. Of the museum's approximately 16,000 accessioned objects from Polynesia, Micronesia, Melanesia, Indonesia and Australia, there are more than 300 barkcloths. Ongoing preservation efforts to facilitate improved research access to the entire barkcloth collection have included the implementation of a 1996 collection condition survey process, and, in 1997, an Institute of Museum and Library Services-supported project for the conservation treatment and re-housing of the barkcloth. In concert with the treatment project's goals, the utilisation of recent electronic technologies will ensure that these collections are more safely available to support broad collaborative museum research efforts.

The Peabody Museum of Archaeology and Ethnology at Harvard University was founded in 1866. Its *basic mission is to preserve, interpret, exhibit, and otherwise make accessible anthropological objects for the benefit of a variety of interested audiences, and to assist anthropological research and teaching* (Pilbeam 1993).

The museum managed a successful institution-wide renovation project in the early 1980s giving rise to much-needed expanded storage facilities for the ethnographic collections and a new storage space for the archaeological ceramic and stone collections. This major preservation effort encouraged more efficient storage use and research access to the collections as a whole, and served to increase awareness of the importance of the museum's large and

early collections of material culture and its associated paper and photographic archival documentation. Older long-standing exhibitions were dismantled, primarily between 1987 and 1993, with new installations completed shortly thereafter. The Oceanic Hall was partially renovated and a new exhibit of 900 objects with 24 conserved barkcloths opened in 1990.

The museum implemented a museum-wide general condition survey and an environmental assessment in 1991 resulting in a long-range preservation/ conservation plan. Several collection-specific condition surveys have been implemented or are being planned. With funding from the museum, the Institute of Museum Services (IMS), the National Science Foundation (NSF) and private sources, the museum successfully improved preservation and storage of its large and important photographic archives. With grant funding from IMS, the museum staff completed the reformatting of over 45,000 catalogue cards and the re-sleeving and re-housing of about 110 linear metres of 19th- and 20th-century accession-related paper documents. The recently funded conservation treatment project for the Pacific barkcloth collections focused on documentation, stabilisation and re-housing concerns.

Ongoing efforts to support research initiatives and to define future preservation efforts for the collections as a whole, occurs through various collections care activities: environmental monitoring, integrated pest management, security and emergency preparedness planning and storage improvement projects such as custom-designed object supports and object containerisation of fragile collections.

Collection history and research

The museum's earliest accessions (1867 and 1869) of barkcloths and associated manufacturing tools, design and dye materials came through donations by the Boston Athenaeum, the Massachusetts Historical Society, the Smithsonian and the Boston Marine Society. Several tapa pieces are believed to have been collected originally during the US Exploring Expedition of 1838–42. Items from the Boston Museum collection accessioned into the Peabody Museum in 1899 were amassed much earlier in the 19th century by Moses Kimball whose diverse Pacific collections derive from numerous islands including Gilbert (now Kiribati), Carolines, Hawai'i, Easter and Marquesas Islands. Figure 7.1 shows a Raiatea headdress constructed with numerous layers of very fine barkcloth (Boston Museum collection, 99-12-70/53545). Alexander Agassiz, Director of Harvard's Museum of Comparative Zoology, 1873–1898, and William McMichael Woodworth contributed to the museum, photographs

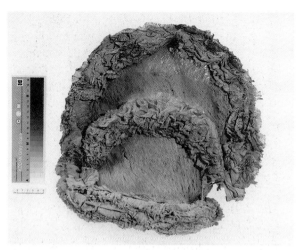

Figure 7.1 Tapa headdress, Raiatea, Society Islands, Peabody Museum Photographic Archives No. N34198. (*Courtesy of Hillel Burger, Peabody Museum of Archaeology and Ethnology*)

and material culture from islands such as Cook, Tonga, Fiji, Samoa, Tuvalu and Society. Many of these late 19th-century photographic images depict manufacturing techniques and related traditions no longer practised, and are illustrative of household or ceremonial uses of these barkcloths (Figs 7.2 and 7.3). Some of the largest accessions (98-8; 99-15; 00-8; 11-2) of tapa pieces,

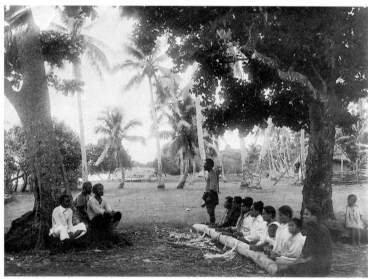

Figure 7.2 Tapa making, beating bark, Polynesia, Kingdom of Tonga. Photograph taken by William McM. Woodworth, 1899, Peabody Museum Photographic Archives Cat. No. H25624. (*Courtesy of Hillel Burger, Peabody Museum of Archaeology and Ethnology*)

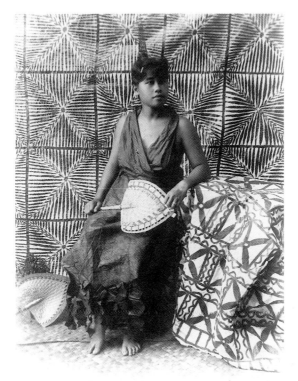

Figure 7.3 Princess, Samoa. Unknown photographer, 1900. Peabody Museum Photographic Archives Cat. No. H24752. (*Courtesy of Hillel Burger, Peabody Museum of Archaeology and Ethnology*)

tools and raw materials were donated or collected for the museum by Agassiz and/or Woodworth.

Current inventory records indicate holdings of more than 300 accessioned barkcloths, with about 170 from the Polynesian region (the majority from the Samoan and Hawaiian Islands). There are over 60 Melanesian pieces primarily from the Fijian islands; several barkcloths originate from Vanuatu and Solomon Islands. Striking surface decoration simulating the appearance of a constructed twined cloth is noted on a 19th-century Santa Cruz barkcloth mat (Fig. 7.4) purchased with 83 other items including fishing gear and weapons in 1923. The barkcloths from Indonesia, Micronesia, Australia, and south-east Asia account for the smallest percentage, and of special note, are several barkcloth coats from Borneo collected in 1897 by W. H. Furness, III.

Dr Simon Kooijman, curator for the Oceanic collections of the Rijksmuseum voor Volkenkunde in Leiden, Holland from 1955 to 1980, was one of the first scholars to publish on the Pacific barkcloth holdings in the

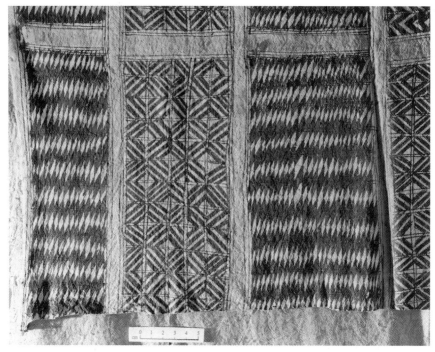

Figure 7.4 Detail of a painted *lepau* (tapa), Santa Cruz Group, Solomon Islands. Peabody Museum Object 23-47-70/D1803, Peabody Museum Photographic Archives H34197. (*Courtesy of Hillel Burger, Peabody Museum of Archaeology and Ethnology*)

Peabody Museum. In 1964, he visited the Peabody Museum and surveyed the collection as it was then accessible to him. He photographed more than 50 barkcloths and provided photographic details of some of the cloths in his 1972 publication *Tapa in Polynesia*. In recent years, several Harvard students have utilised the exhibited barkcloths for research projects, and several individuals from Hawai'i and from other island areas have inquired about the general collections in the interest of reintroducing specific techniques into their communities.

The tapa items in the Peabody Museum, representing about 200 years of barkcloth making, range from translucent, white, very thin and finely beaten barkcloths to medium brown-toned heavy ones of crudely pounded bark fibre. The formats are as equally diverse from 10cm × 15cm sample books to large ceremonial barkcloths over 140m long. There are several Hawaiian sleeping covers, known as *kapa moe*, composed of multiple, separate individual layers affixed across one end with cordage. Other tapas are constructed and served as dresses, shirts or breech cloths. Barkcloths may be decorated on one or both sides with thin or thick applications of paint and/or dye with colours ranging

Figure 7.5 Detail of a watermark of one of five cloths from a Hawaiian *kapa moe*. Peabody Museum Object 76-51-70/11012. (*Courtesy of the Conservation Department, Peabody Museum of Archaeology and Ethnology*)

from yellows, reds, blues, to various tones of browns and blacks appearing matt or glazed in appearance. Some cloths show a watermark resulting from the use of a carved beater (Fig. 7.5), while others feature finely cut designs or perimeter fringes.

Utilisation of the Pacific material culture collections in public exhibits

The Peabody has for most of its 135 years exhibited Pacific material culture, making available more than 4,000 objects through various display practices. More than 300 war clubs were on display in the early 20th century emphasising the interest and study of warfare and ceremonial activities; tapa pieces appear on the walls or floors of the exhibit cases upon which wooden objects and other materials are positioned. A Fijian *masi*, one of the longest ones in the collection, is presented in a rolled and folded state at the bottom of one of the cases (Fig. 7.6).

Between 1988 and 1989, the gallery was partially renovated and a new selection of objects (just 900 instead of the previous 2500) was prepared for exhibition. Conservation treatment of the selected mats, woven and constructed textiles, barkcloths and several three-dimensional objects was completed along with the fabrication of custom-designed display supports. The new installation features a fairly representative selection of the museum's

Figure 7.6 Polynesian and Melanesian material culture in the Oceanic Gallery prior to the 1980s. Peabody Museum Photographic Archives Photo No. N31334d. (*Photograph taken by Hillel Burger, Peabody Museum of Archaeology and Ethnology*)

holdings from Polynesia, Melanesia, Micronesia, Indonesia and Australia with models of outrigger canoes and other vehicles of transportation, fishing implements, tools for cultivating, preparing and serving food, musical instruments, clothing items and mats, trade goods and toys and games. Of the tapas on exhibition, the majority represent Polynesian islands featuring cloths from Samoa, Hawai'i, Tonga, Cook and Society. Melanesian barkcloths (especially Fijian) are featured along with barkcloths from New Guinea and Borneo.

Conservation treatment plans for barkcloth items prepared for exhibition in 1990

The treatment strategy for the barkcloth was worked out during 1988, with parameters defined by the condition and/or preservation needs of the cloths, and the existing exhibit case configuration. Small tapas were designed for flat,

Figure 7.7 Current installation in the Oceanic Gallery, 1990 featuring barkcloth displayed flat on slanted supports and rolled on large diameter tubes. (*Courtesy of the Conservation Department, Peabody Museum of Archaeology and Ethnology*)

slanted display. All others were intended for rolled display in which a small length of the barkcloth would be extended over or under a padded fabric-covered tube. The photograph of the current installation (Fig. 7.7) shows these two main display methods.

The treatment approach for the 24 barkcloths selected was relatively non-invasive in which only the most problematic, structural or edge tears were stabilised. All cloths were photographed folded as received in the conservation laboratory, examined, and object description and condition notes were recorded. Prior to humidification, which was necessary to enable safe unfolding of the barkcloths, dyes and pigments were tested for moisture sensitivity. Surface cleaning using a HEPA-filtered vacuum cleaner with rheostat control for low suction, was completed as possible prior to humidification. Further surface cleaning techniques were employed as needed during the relaxing and unfolding phase. Black soot and fine black particulate soiling matter was often further removed with the use of small sections of vulcanized rubber sponge, followed by vacuuming. The majority of the barkcloths were locally humidified using a layering technique with a strip of Goretex laminate membrane, or a layer of polyester non-woven fabric (Reemay), then moistened blotting paper. The layers were weighted lightly with a 3mm acrylic plate. Once the moistened paper strips were removed,

slightly more weight was applied and the tapa was left until dry; or in some cases, dry blotting paper was inserted after removal of the moist paper and then weights applied. Additional local humidification for further relaxation of storage creases occurred as needed. After humidification tears were stabilised from the under side with appropriately toned small strips of Japanese paper mulberry tissue paper (as appropriate to the barkcloth thickness and structural needs) and aqueous adhesives. Wheat and/or rice starch paste were the preferred adhesives in most cases. The average conservation treatment time required between five and 15 hours. The lengthiest conservation treatments (over 20 to 30 hours) involved very large tapas, such as the Fijian *masi* (98-8-70/51704) that was in excess of 133m (Fig. 7.8) or those with extensive perimeter tears or storage tears along fold lines. Many of the barkcloths were very pliable overall, except in regions of heavier paint or starch applications. A Samoan off-white *siapo mamanu* (19-39-70/D1272), decorated with centipede-like motifs in a dark brown paint, required extensive tear repairs in the painted regions and along painted perimeters (Fig. 7.9).

Figure 7.8 *Masi* (tapa), Fiji Islands. Peabody Museum Object 98-8-70/51704. Conservation treatment in process for exhibition: localised humidification with moistened blotters with subsequent rolling on a large diameter tube with interleaving tissue at perimeter fringes (*Courtesy of the Conservation Department, Peabody Museum of Archaeology and Ethnology*)

Figure 7.9 *Siapo mamanu* (hand-painted tapa), Samoan Islands illustrating losses of barkcloth substrate in proximity to the dark brown paint. Peabody Museum Object 19-39-70/D1272. (*Courtesy of the Conservation Department, Peabody Museum of Archaeology and Ethnology*)

To summarise, the treatment strategy employed for the conservation of the barkcloths prepared for exhibition in 1990 involved the following:

- Photographic and written documentation
- Surface cleaning by low-suction vacuuming
- Testing of dye/pigment regions for sensitivity to moisture
- Local humidification of storage crease lines using moistened blotter paper strips and chamber humidification for large tightly creased and very stiffened barkcloths
- Stabilisation of the most vulnerable areas such as structural or perimeter tears
- Final photographic documentation in colour and black and white
- Display support fabrication

Mount design and installation of the selected objects in the Oceanic Gallery was a collaborative effort involving the exhibition preparators and the ethnographic collection manager with conservation consultation.

Collection management and future conservation planning for the barkcloths in current storage

Collection condition assessment of Pacific barkcloth in storage

In the early 1980s, when the collections were moved into the renovated spaces, most items were simply placed onto the new shelving units without supports or intervention. The tapas were placed folded and stacked as they were previously (Fig. 7.10). The barkcloth, plaited mats and other plant material collections were clearly identified as a preservation priority. Significantly improved safe and efficient research and staff access has long been needed. The exhibition/conservation process for the 24 barkcloths selected for the new installation has served, much like a pilot project, for understanding the scope of conservation needs for the remaining tapas and was useful in the development of preservation initiatives for the entire collection. A 1996 collection-specific condition survey of the barkcloth collections was initiated to provide updated information about the current condition of the long-term folded and stacked state of the cloths in storage. The survey was to assist in identifying the range of preservation problems, those potentially attributed to specific inherent manufacturing components and those due to inappropriate

Figure 7.10 Folded and stacked barkcloth items in storage (1997) to be conserved and re-housed under the grant-funded conservation treatment project. (*Courtesy of the Conservation Department, Peabody Museum of Archaeology and Ethnology*)

Worksheet for documentation of tapa from the Pacific Islands

Accession number: _____

Country/island: _____ Examination date: _____

Object dimensions: _____ / _____
 (before) (after)

Photography: BT _____ DT _____ AT _____

Object description

☐ SUBSTRATE
 ☐ cloth thickness/weight
 ☐ layers of individual sheets
 (multiple____ single____)
 ☐ texture (evenly beaten/rough, etc.)
 ☐ overall tone (off-white; brown)
 ☐ grain direction
 ☐ original processing foldlines
 ☐ patches and/or fills over branch holes
 or tears
 ☐ length of barkcloth strips

☐ FABRICATION
 ☐ edge finish
 ☐ joins
 ☐ type (overlap, etc.)
 ☐ method (felting; pasting; sewing)

☐ DECORATION
☐ surface texture (embossed; beater pattern,
 ribbing, etc.); distance apart; direction
☐ applied pigment/dye (colors; sheen; etc)
☐ one or both sides
 ☐ design pattern:
 ☐ techniques:
 ☐ freehand
 ☐ rubbing from a design tablet
 ☐ stenciling
 ☐ lining
 ☐ printing
 ☐ smoking
☐ surface coatings
☐ maker's marks

☐ EVIDENCE OF USE
☐ soiling
☐ fingerprints
☐ folds or creases due to use
☐ ethnographic or original repairs/alterations:
☐ other:

☐ COLLECTOR'S MARKS; MUSEUM
NUMBER/TAG

Material analysis

☐ FIBRE IDENTIFICATION
☐ MICROCHEMICAL TESTS:
 ☐ lignin (phloroglucinol)
 ☐ starch (iodine/potassium iodide)
 ☐ pH (ColorPhast indicator strips)
 ☐ Munsell Color Notation:

Condition

☐ STRUCTURAL
 ☐ flexibility
 ☐ delamination
 ☐ tears; abrasions; losses:
 ☐ deterioration/embrittlement due to
 pigment/dye

☐ APPLIED PIGMENT/DYE DECORATION
 ☐ cupping/cracking
 ☐ flaking paint layer
 ☐ fading
 ☐ bleeding

☐ WATER OR LIQUID STAINING/DAMAGE

☐ DAMAGE DUE TO STORAGE
 ☐ storage foldlines/creases
 ☐ soiling
 ☐ other:

☐ BIOLOGICAL
 ☐ insect:
 ☐ rodent:
 ☐ mold:

☐ USE OF FUMIGANTS
 ☐ p-Dichlorobenzene
 ☐ Other:

☐ CHEMICAL
 ☐ surface salts
 ☐ exudations
 ☐ other:

☐ PREVIOUS REPAIRS
 ☐ Method: pressure-sensitive tape/adhesive;
 sewn or attached backing material/patches
 ☐ Stability and condition of repairs:

☐ PREVIOUS DISPLAY

Figure 7.11 Documentation worksheet prepared for use during implementation of the IMLS grant-funded conservation project (Harvard Peabody Museum, Conservation Department, 1998).

storage methods. The survey data would be useful in the preparation of a future grant proposal where staffing needs, conservation treatment needs and options for re-housing with associated costs would be outlined with a workable implementation time frame.

Grant-funded conservation treatment of the barkcloth collection

Based on the findings from the 1996 condition survey and the 1989–90 exhibition preparation process, a treatment and re-housing grant proposal was initiated and submitted to IMLS in February 1997. The 1997 IMLS grant supported the necessary visual and written documentation, archival research, conservation treatment and improved re-housing of the tapas. The project was designed to address basic stabilisation needs and material analysis of fibres, dyes/pigments, oils and other inherent components for a selected group.

The Peabody Museum's barkcloth conservation treatment project concluded in the fall of 2000. Two conservators (T. Rose Holdcraft, museum conservator and Kathleen Kiefer, assistant conservator for the IMLS project) with the assistance of eight conservation interns and pre-program conserva-

Figure 7.12 One of several deteriorating barkcloths of Samoan manufacture. Peabody Museum Object 43-32-70/2248. (*Courtesy of the Conservation Department, Peabody Museum of Archaeology and Ethnology*)

tion volunteers implemented the documentation, vacuuming, surface cleaning and partial stabilisation repairs and re-housing of 270 Polynesian and Melanesian cloths between 1998 and 2000. Written documentation was entered into the museum's collection management database with one photographic colour image digitally linked to the corresponding object record. A documentation worksheet (Fig. 7.11) was prepared to enhance standardisation of the data collected from each tapa by the different conservators working on the project during the 2½ year period, as well as to facilitate more efficient data entry into the database. The project included opportunity for material analysis of 10 to 15 severely deteriorating or unstable barkcloths identified during the survey such as the Samoan cloth (43-32-70/2248) featured in Figure 7.12. Material analysis of separated samples from 12 deteriorating acidic cloths was possible through collaboration and participation of Joel (Jablonski) Thompson (then a second-year conservation graduate student at the State University College at Buffalo, Buffalo, New York). Her research is described in a senior specialisation project paper entitled *An Examination of Degraded Samoan Barkcloth from the Collection of the Peabody Museum of Archaeology and Ethnology.*

Figure 7.13 Re-housed barkcloth collection, 2001
(*Courtesy of the Conservation Department, Peabody Museum of Archaeology and Ethnology*)

The final step in the project was to improve physical access and preservation given existing storage space (Fig. 7.13) Protective housings incorporated appropriate interleaving materials. The storage format for each item was dependent on the quality/condition of each cloth after conservation, original methods of construction, pigment/dye application and physical dimensions. Due to cloth construction, condition or due to fragile decorative paint components, flat storage was the preferred option. Smaller cloths were stored flat individually in a low-profile rigid, stackable folder of archival-quality corrugated paperboard material. Larger cloths were stored flat with one or two padded folds and placed individually or in small groups in a stackable lidded box. Folders and boxes, depending on size, are placed in pullout trays or positioned on open shelves. Rolling was selected as the storage option for about 145 cloths. They were rolled individually on a rigid tube (diameters varied between 3 and 6 in.) with appropriate barrier and interleaving materials, and suspended on an aluminium rod.

Future access and global co-operation

The ongoing preservation efforts at the Peabody Museum and the objectives of the partially federally-funded treatment project supports the recently publicised mission and objectives of the Pacific Islands Museum Association (PIMA) for global museum partnerships and for initiatives that increase knowledge of Pacific collections held throughout the world.

With the photographic documentation component of this grant project, it is intended that a visual finding aid will have the potential for wider use via the World Wide Web (see References for website address) as well as through traditional museum catalogues or other visual digitisation projects (e.g. CD-ROM). An on-line electronic catalogue will allow researchers and staff to have access to the digital surrogates of the objects, reducing physical manipulation of these barkcloths. All information resulting from archival research, condition surveys, and conservation treatments are available in part on the museum's collections management database, known as EmbARK or in the conservation department. The treatment project benefits exhibit rotation initiatives, facilitating preservation and public access. An upcoming exhibition in 2002 will feature the conservation project and a selection of the cloths and associated tools and materials for tapa making and decoration not previously documented or published.

References

Kooijman, S. (1972) 'Tapa in Polynesia', *Bernice P. Bishop Museum Bulletin*, 234. Honolulu: Bishop Museum Press, 24–5, 60, 62, 65, 202–205, 222–5, 243, 246, 276, 289–91, 308–309.

Peabody Museum website: www.peabody.harvard.edu/frames.html

Pilbeam, D. 1993. Mission Statement of the Peabody Museum of Archaeology and Ethnology, Harvard University, drafted by Dr David Pilbeam, reviewed and adapted by Dr Rubie Watson, 1999.

Bibliography

Barton, G. and Weik, S. (1994) 'The conservation of tapa', *The Conservator* **18**, 28–40.

Erhardt, D and Firnhaber, N. (1987) 'The analysis and identification of oils in Hawaiian oiled tapa' in *Recent Advances in the Conservation and Analysis of Artifacts*, J. Black (ed.) London: Archetype Publications, 223–7.

Florian, M-L. E., Kronkright, D. P. and Norton, R. E. (1990) *The Conservation of Artifacts Made from Plant Materials*. Los Angeles, CA: The J. Paul Getty Trust.

Jablonski, J. L. (1999) *An Examination of Degraded Samoan Barkcloth from the Collection of the Peabody Museum of Archaeology and Ethnology*. Unpublished senior specialisation project paper at the State University College at Buffalo, Buffalo, New York.

Leonard, A. and Terrell, J. (1980) *Patterns of Paradise: The Styles and Significance of Barkcloth around the World*. Chicago: Field Museum of Natural History.

Munro, S. N. (1981) 'The conservation of a Hawaiian sleeping tapa', *ICOM Committee for Conservation 6th Triennial Meeting Preprints* 81/3/3-3.

Neich, R. and Pendergast, M. (1998) *Traditional Tapa Textiles of the Pacific*. New York: Thames & Hudson.

Rose, R. G., Turchan, C., Firnhaber, N. and Brown, L. O. (1988) 'The Bishop Museum tapa collection: conservation and research into special problems', *Bishop Museum Occasional Papers* **28**, 1–34.

Smidt, D., ter Keurs, P. and Trouwborst, A. (1995) *Pacific Material Culture: Essays in honour of Dr. Simon Kooijman on the occasion of his 80th birthday*. Leiden: Rijksmuseum voor Volkenkunde.

Watson, R. S., Dorhout, N. J. and Rogers, J. R. (1996) 'Pacific collections at the Peabody Museum of Archaeology and Ethnology at Harvard University: The Early Years', *Pacific Arts, The Journal of the Pacific Arts Association* **13 & 14**, 57–68.

The conservation and storage of barkcloths at the Manchester Museum

Christine Murray and Emily Johnson

Introduction

The Manchester Museum ethnology collection contains approximately 100 barkcloths from Fiji, Hawaii, Samoa, Tahiti, Tonga, Papua New Guinea and Uganda. Most of this material was collected around the turn of the century and since that time has been kept largely in a folded state in a series of dirty storerooms, with no environmental control. Storage conditions for this material were therefore far from ideal. Although the relative humidity (RH) in the stores is now controlled, the barkcloths have remained in folded state, usually in open polyethylene bags and often squashed down with other items on top. Therefore, several years ago, a programme of conservation and storage was set up to improve this situation in order to give the material a longer life and improve access to the collection for study.

Conservation

Condition

Although the barkcloths have been kept in poor storage conditions for many years, they have not generally suffered from any severe damage and degradation. The cloths are heavily folded and compressed and this has led to fibre damage, cracking and damage to surface decoration. Some of the barkcloths are very brittle with tears and missing areas, probably due to the breakdown of cellulose fibres. This type of damage is particularly evident around some

of the painted and dyed areas, where acidic components of the dye or pigments have caused localised damage. Some of the barkcloths have delaminated. Very little moth or insect damage was found on any of the barkcloths conserved and there is only a small amount of damage and staining due to mould growth. Some general staining is visible on some of the barkcloths, but it is impossible to tell whether this has occurred as a result of poor storage or during original use.

Cleaning

Most of the barkcloths that have been conserved so far have required very little cleaning. As the barkcloths have been kept in a folded state, all the accumulated dust sits on the outer surfaces and is easily removed with the use of a soft paintbrush and air blower or vacuum cleaner before the barkcloth is relaxed in the humidity tent. Where the dirt is more widely distributed, the barkcloth is brushed and carefully vacuumed in the humidity tent as it is unfolded. With the more stubborn black 'Manchester dirt', the use of a 'chemical sponge' (rubber latex) has been found to be extremely effective. The sponge is gently dabbed onto the surface of the barkcloth to lift off the dirt. However, this method of cleaning is not suitable where the barkcloth is very brittle or delaminating as it would cause too much surface damage. Apart from the barkcloth from Samoa (see Chapter 6) so far we have not undertaken any wet cleaning, deacidification treatments or repairs to torn or missing areas.

Humidification

Each barkcloth is unfolded inside a purpose-built humidity tent (Fig. 8.1). The atmosphere within the tent is raised to about 65–70% RH using a Salton portable ultrasonic humidifier, with the hose placed through a hole in the top of the tent. The RH is controlled by a humidistat placed within the tent. A plastic drip tray, sitting on some acid-free paper towelling on top of the barkcloth, is used to catch any drips from the hose. A small 12-volt fan, controlled by the humidistat, is placed in the tent to circulate the water vapour to ensure that the RH is kept at a constant level throughout the tent. A chart recorder is also placed within the tent to record the conditions. The folded barkcloth is left for 24–48 hours or longer, depending on the size and condition of the cloth. The barkcloth is then gradually unfolded – sometimes over several days – and once unfolded, left for a further 24 hours to fully relax. The creases and folds are then carefully smoothed and small bags of lead shot or sand,

113

Figure 8.1 The humidity tent

covered with acid-free tissue, are placed around the edges of the cloth to hold the barkcloth flat. Once the weights are in place, the RH in the tent is kept at the same level (65–70%) for 6–24 hours to ensure that the barkcloth is fully relaxed in its newly flattened state. The tent is then opened and the humidifier switched off to allow the RH to drop to 50–55% allowing the barkcloth to shrink, pulling out the creases and folds. Often the effects of this treatment are minimal, so over a period of 4–8 weeks the process is usually repeated many times until the barkcloth is flattened out – or is as flat as it can safely be made such as in the cases of very weak or torn cloths, or thick, heavily folded and painted cloths. Stubborn creases and folds are flattened by smoothing out the cloth, after which weights are placed directly on top of the creases. In particularly stubborn areas, the hose from the humidifier is placed directly over the area for a few minutes to humidify and soften it more fully before weights are placed on top. In the case of large barkcloths, the humidified cloth is partly unfolded and flattened, rolled onto an acid-free cardboard tube and then unfolded further until the whole cloth is treated (Fig. 8.2).

Storage

After humidification the barkcloth is usually rolled onto an acid-free cardboard tube lined with acid-free tissue. It is then covered with a layer of acid-free tissue

Figure 8.2 Two barkcloths inside the humidity tent during conservation

as it is rolled to prevent the barkcloth being rolled on itself. Rolling barkcloth onto a tube is far from easy – the material is seldom uniform in size or shape and often the old storage folds cannot be totally eliminated – so it usually takes several attempts, with at least two people rolling. This often results in the cloth being rolled at an odd angle to ensure the best fit. Although not an ideal method of storage for barkcloths, with very limited storage space it is the best that can be achieved at present. This method also restricts access to the barkcloths for study, as it would be quite damaging to unroll and re-roll the material regularly. Once the barkcloth is rolled onto the tube, it is covered with more acid-free tissue, labelled and placed on a shelf in the ethnology stores (Fig. 8.3). The RH in the stores is controlled at about 50–55%. In the past, the rolls of barkcloth were encased in polyethylene after conservation but the sheeting attracts dust and dirt, so now the rolls are left with just the acid-free tissue covering which can be easily dusted or replaced if they becomes too dirty.

Special or interesting barkcloths that are small or very degraded or damaged, or those to which frequent access is required are not placed on rolls. These are usually laid on an acid-free boards covered with acid-free tissue and stored horizontally on metal racking. Then the barkcloths are covered with acid-free tissue, Melinex (polyester film) or polyethylene. This type of storage is ideal as it allows examination and study at any time, however there is very limited storage space of this type and it is almost at full capacity. The cost of large, strong acid-free boards is very high; this also makes it impractical for the storage of the majority of the collection. Many of the barkcloths are too large to lie on the boards available without being folded. Large boards can be joined

115

Figure 8.3 Barkcloth storage

together but strength is lost and then shelf space has to be found for the oversized unstable boards. The support of weak boards with sheets of wood or block board adds enormously to the weight and therefore restricts access. Each item of barkcloth is examined to assess condition, size, importance and accessibility to determine the type of storage that will be suitable.

The problem of how to store extremely large barkcloths has not as yet been addressed. There are a few that would appear to be far too big to be put on a roll or several boards, even if an area large enough to unfold them could be found.

Conclusion

The conservation and storage programme discussed in this paper has greatly improved access to the collection and its condition. To date approximately one-third of the barkcloth collection has been conserved. Previously many of the objects had never been fully examined and it is now hoped that some of this

material will be displayed in a new gallery. The volume required for the storage of the barkcloths rolled onto acid-free cardboard tubes, or on flat acid-free boards, is very large in comparison with the space occupied previously by the untreated, folded and cramped barkcloths. Inevitably this presents problems since storage space is limited but storage is continuously being improved and upgraded. The aim in the future is to continue the conservation programme and to install purpose-built racking upon which the acid-free cardboard tubes holding the barkcloths can be hung.

Acknowledgements

I would like to thank C. Velson Horie and Dr George Bankes for their help and advice; Roy Garner for his invaluable assistance in setting up and maintaining the humidity tent; Michaela Augustin-Jeutter for her help, and Geoff Thompson for his photographs and advice.

Bibliography

Bakken, A. and Aarmo, K. (1981) 'A report on the treatment of barkcloth', *Proceedings of the 6th Triennial ICOM Conference*, Ottawa, 5.

Barton, G. and Weik, S. (1994) 'The conservation of tapa', *The Conservator* **18**, 28–40.

Ewins, R. (1982) *Fijian Artefacts. Tasmanian Museum and Art Gallery Collection.* Hobart: Tasmanian Museum and Art Gallery.

Florian, M-L. E., Kronkright, D. P. and Norton, R. E. (1990) *The Conservation of Artifacts Made from Plant Materials.* Los Angeles, CA: The J. Paul Getty Trust.

Note

At the time of writing this paper, Christine Murray was a Conservator and Emily Johnson was on a placement from the Durham MSc conservation course at the Manchester Museum.